D0392903

*The Tate Guide to
Modern Art Terms*

ilson, Simon, 1942–
he Tate guide to
odern art terms /
008.
3305218537490
u 01/12/10

The Tate Guide to Modern Art Terms

Simon Wilson
and Jessica Lack

Tate Publishing

First published 2008 by order of the Tate Trustees
by Tate Publishing, a division of Tate Enterprises Ltd,
Millbank, London SW1P 4RG
www.tate.org.uk/publishing

© Tate 2008

All rights reserved. No part of this book may be reprinted or reproduced or utilised in any form or by any
electronic, mechanical or other means, now known or hereafter invented, including photocopying and
recording, or in any information storage or retrieval system, without permission in writing from the publishers

A catalogue record for this book is available from the British Library
ISBN 978 1 85437 750 0

Distributed in the United States and Canada by Harry N. Abrams, Inc., New York
Library of Congress Control Number: 2008934164

Designed by Turnbull Grey
Cover graphics by Alan Kitching
Reproduction by DL Interactive Ltd, London
Printed in Great Britain by TJ International, Padstow

Measurements of artworks are given in centimetres, height before width.

*Introduction*_Human beings are natural labellers – it is how we make sense of the world. This glossary is an attempt to bring together and define the meaning of some of the best known but also some of the more obscure of the myriad labels that have been given to the, often confusingly, varied phenomena of what we call modern art. It also includes definitions of materials and techniques.

In defining terms we have tried to track them back to source. A basic example, and a historical starting point for this glossary, is the origin of Impressionism in the title of Claude Monet's painting *Impression, Sunrise*, exhibited to general derision at what subsequently became known as the *First Impressionist Exhibition* in Paris in 1874. More recently, the term abject, much used in relation to art in the past decade or so, first appeared in its art context in the writings of the cultural theorist Julia Kristeva.

The aim of this book is to provide a compact, portable, affordable, ready-reference work, but within the constraints of that format we have tried to provide as much information as possible.

I began thinking about these definitions when I was writing the Tate online glossary of international modern and British art terms. To my original definitions, Jessica Lack has added 100 terms relating specifically to contemporary art; for those terms relating to materials and techniques we have been fortunate to be able to call on the expertise of the Conservation Department at Tate. Additional terms have been written by Tate's Curatorial, Research, Publishing and Media departments. Between us I hope we have provided a reliable guide through the complex terminologies that surround modern and contemporary art.

Simon Wilson

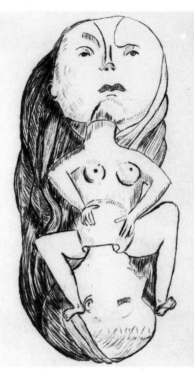

abject art
Louise Bourgeois
Birth 1994
Drypoint on paper
23.6 x 18.2
Tate. Purchased 1994

*AAA*_ see <u>American Abstract Artists</u>

*Abbaye de Creteil*_In 1906 a group of French
writers, artists and composers established the Abbaye
de Creteil at a villa in Creteil south-east of Paris.
The movement included the painters Albert Gleizes,
Charles Berthold-Mahn and Jacques d'Otemar, the
poets Charles Vildrac, Georges Duhamel, René Arcos,
Alexandre Mercereau, Jules Romains and Henri-
Martin Barzun, the composer Albert Doyen, and the
printer Lucien Linard. The group was partly inspired
by the French Renaissance writer François Rabelais,
who had written about a self-supporting commune
in a monastery called the Abbaye de Thelema that
had championed group labour and intellectual self-
improvement. The Abbaye de Creteil community only
lasted until February 1908, yet in its brief existence it

supported the work of Roger Allard, later to become
a proponent of Cubism and the works of the leading
French poet Pierre-Jean Jouve.

*abject art*_The abject is a complex psychological,
philosophical and linguistic concept developed by
Julia Kristeva in her 1980 book *Powers of Horror*.
She was partly influenced by the earlier ideas of the
French writer, thinker and dissident <u>Surrealist</u> Georges
Bataille. It can be said, very simply, that the abject
consists of those elements, particularly of the body,
that transgress and threaten our sense of cleanliness
and propriety. Kristeva herself commented: 'refuse
and corpses show me what I permanently thrust
aside in order to live.' In practice the abject covers all
the bodily functions, or aspects of the body, that are
deemed impure or inappropriate for public display or
discussion. The abject has a strong <u>feminist</u> context, in
that female bodily functions in particular are 'abjected'
by a patriarchal social order. In the 1980s and 1990s
many artists became aware of this theory and reflected
it in their work. In 1993 the Whitney Museum, New
York, staged an exhibition titled *Abject Art: Repulsion
and Desire in American Art*, which gave the term a
wider currency in art. Cindy Sherman is seen as a key
contributor to the abject in art, as well as many others
including Louise Bourgeois, Helen Chadwick, Paul
McCarthy, Gilbert and George, Robert Gober, Carolee
Schneemann, Kiki Smith and Jake and Dinos Chapman.
(See also <u>body art</u>)

*abstract art*_The word 'abstract', strictly speaking,
means to separate or withdraw something from
something else. In that sense it applies to art in which
the artist has started with some visible object and
abstracted elements from it to arrive at a simplified
or schematised <u>form</u>. The term is also applied to art
using forms that have no source at all in external reality.

These forms are often, but not necessarily, geometric. Some artists of this tendency have preferred terms such as <u>Concrete art</u> or <u>non-objective art</u>, but in practice the word 'abstract' is used across the board and the distinction between the terms is not always obvious. A cluster of theoretical ideas lies behind abstract art: the idea of art for art's sake – that art should be purely about the creation of beautiful effects; the idea that art can or should be like music – that just as music is patterns of sound, art's effects should be created by pure patterns of form, colour and line; the idea, derived from the ancient Greek philosopher Plato, that the highest form of beauty lies not in the forms of the real world, but in geometry; the idea that abstract art, to the extent that it does not represent the material world, can be seen to represent the spiritual. In general, abstract art is seen as carrying a moral dimension, in that it can be seen to stand for virtues such as order, purity, simplicity and spirituality. Pioneers of abstract <u>painting</u> were Wassily Kandinsky, Kasimir Malevich and Piet Mondrian from about 1910–20. A pioneer of abstract <u>sculpture</u> was the Russian Constructivist Naum Gabo. Since then abstract art has formed a central stream of modern art.

*Abstract Expressionism*_Term applied to new forms of <u>abstract art</u> developed by American painters in the 1940s and 1950s. The Abstract Expressionists were mostly based in New York City, and also became known as the <u>New York School</u>. The name evokes their aim to make abstract art that was also expressive or emotional in its effect. They were inspired by the <u>Surrealist</u> idea that art should come from the unconscious mind, and by the <u>Automatism</u> of Joan Miró. Within Abstract Expressionism were two broad groupings. These were the so-called Action painters led by Jackson Pollock and Willem De Kooning (see <u>gestural</u>) and the <u>Colour Field painters</u>, notably Mark Rothko, Barnett Newman and Clyfford Still. The Action painters worked in a

spontaneous improvisatory manner, often using large brushes to make sweeping gestural marks. Pollock famously placed his canvas on the ground and danced around it, pouring paint direct from the can or trailing it from the brush or a stick. In this way they placed their inner impulses directly onto the canvas. The Colour Field painters were deeply interested in religion and myth. They created simple compositions with large areas of a single colour intended to produce a contemplative or meditational response in the viewer.

*Abstraction-Création*_Association of abstract artists set up in Paris in 1931 with the aim of promoting abstract art through group exhibitions. It rapidly acquired membership of around 400. Leaders were Auguste Herbin and Georges Vantongerloo, but every major abstract painter took part including such figures as Naum Gabo, Wassily Kandinsky and Piet Mondrian. In Britain members of the modernist groupings the Seven and Five Society and Unit One, kept in close touch with Abstraction-Création. Abstraction-Création embraced the whole field of abstract art, but tended towards the more austere forms represented by Concrete art, Constructivism and Neo-Plasticism. Regular exhibitions were held until 1936 and five annual publications were issued.

*Academia Altamira*_see School of Altamira

*academic art*_Art made according to the teachings of an art academy. In the nineteenth century the art academies of Europe became extremely conservative, resisting change and innovation. They came to be opposed to the avant-garde and to modern art generally. The term 'academic' has thus come to mean conservative forms of art that ignore the innovations of modernism.

*Académie Colarossi*_Art school in Paris
established in the nineteenth century as an alternative
to the official Ecole des beaux-arts. Comparable to and
slightly less famous than the Académie Julian. Like the
Julian, the Colarossi admitted women and allowed them
to draw from the nude male model. Artists who attended
include John Banting, William Gear, George Grosz,
Elsie Henderson, Hans Hofmann and Samuel Peploe.

*Académie Julian*_Art school in Paris established in
1868 by Rodolphe Julian. It became a major alternative
training centre to the official Ecole des beaux-arts,
especially for women who were not admitted to the
Ecole des beaux-arts until 1897. Also, at the Julian
women were permitted to draw from the nude male
model. In 1888–9 Pierre Bonnard and Edouard Vuillard
were students there and, together with some others,
formed the symbolist group the Nabis. The Académie
Julian was popular with foreign art students and many
leading modern artists spent time there.

*academy*_The first art academies appeared in Italy
at the time of the Renaissance. They were groupings
of artists whose aim was to improve the social and
professional standing of artists, as well as to provide
teaching (see Ecole des beaux-arts). To this end they
sought where possible to have a royal or princely
patron. Previously, painters and sculptors had been
organised in guilds, and were considered mere artisans
or craftsmen. Academies became widespread by the
seventeenth century, when they also began to organise
group exhibitions of their members' work. This was a
crucial innovation, since for the first time it provided a
market place, and began to some extent to free artists
from the restrictions of direct royal, church or private
patronage. The most powerful of the academies was the
French Académie Royale de Peinture et de Sculpture,
established in 1648 and housed in the Palais du Louvre

in Paris. The Académie began holding exhibitions in 1663 and opened these to the public from 1673. After the French Revolution the name was changed to plain Académie des Beaux Arts. The London Royal Academy was founded in 1768 with Joshua Reynolds (later Sir Joshua) as its first president. By the mid-nineteenth century the academies had become highly conservative and, by their monopoly of major exhibitions, resisted the rising tide of innovation in naturalism, realism, Impressionism and their successors. The result was that alternative exhibiting societies were established and private commercial art galleries began to appear (see salon). The academies were bypassed and the term 'academic art' now has the pejorative connotation of conservative or old-fashioned.

*acrylic paint*_A dispersion of pigments in a synthetic acrylic resin produced from acrylates and/or methacrylates. Acrylic paint dries as the liquid vehicle evaporates, and the resulting polymer-chains then deform and coalesce to form the paint film. While acrylic paints are generally thought to be very fast drying, thick applications may take months or even years to fully dry. Artist acrylic paints were first made in the 1950s using poly (n butyl methacrylate) resin dissolved in solvent (mineral spirits or turpentine) with pigments and other minor components. The next type developed in the 1960s was the acrylic emulsion paint which remains so popular today. These are thinned (and brushes cleaned) using water; however, once dry, the paint films are water-resistant.

*Actionism*_English version of a general German term for Performance art, but it was specifically used for the name of the Vienna-based group Wiener Aktionismus founded in 1962. The principal members of the group were Gunter Brus, Hermann Nitsch and Rudolph Schwarzkogler. Their 'actions' were intended to

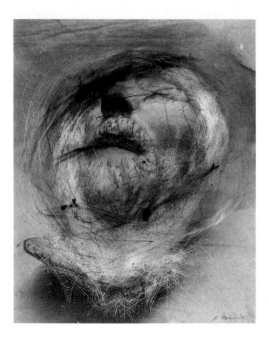

Actionism
Arnulf Rainer
Untitled (Death Mask) 1978
Oil, pastel and
photograph on paper
60.9 x 50.5
Tate. Purchased 1982

highlight the endemic violence of humanity and were
deliberately shocking, including self-torture and quasi-
religious ceremonies using the blood and entrails
of animals. Nitsch gave his ceremonies the general
title of Orgies-Mysteries Theatre. In America, Dennis
Oppenheim and in Britain, Stuart Brisley performed
actions in a spirit that can be related to Wiener
Aktionismus. A less violent but no less anguished
Vienna Actionist of the time was Arnulf Rainer.

*Aesthetic Movement*_Flourishing in Britain in
the 1870s and 1880s and later popular in the USA, the
Aesthetic Movement was important in both fine and
applied arts. Critic Walter Hamilton published his book
The Aesthetic Movement in England in 1882. Promoting
the cult of pure beauty in art and design, its rallying
cry was 'art for art's sake', meaning art foregrounding
the purely visual and sensual, free of practical, moral
or narrative considerations. Examples of the style in

painting can be found in J.A.M. Whistler and Albert Moore and certain works by Frederic Leighton. Japan was an important influence especially on Whistler and on Aesthetic design (see Japonisme). In applied arts it was part of the revolution in design initiated by William Morris with the foundation of Morris & Co. in 1862. From 1875 the style was commercialised by the Liberty store in London, which later also popularised Art Nouveau.

*Agit-prop_*A contraction of the Russian words *agitatsiia* and *propaganda* in the title of the Department of Agitation and Propaganda set up in 1920 by the Central Committee of the Soviet Communist Party. From then on Agit-prop was an omnipresent activity in the Soviet Union. Intended to control and promote the ideological conditioning of the masses, it took many forms such as palaces of culture, Agit-prop trains and cars covered with slogans and posters, poster campaigns, and countless agitation centres, or 'agitpunkts'. Books and libraries also played an important role in the Agit-prop enterprise. In the early years avant-garde artists, particularly those associated with the Constructivists, contributed to Agit-prop manifestations, especially poster designs. Today the term has come to refer to any cultural manifestation with an overtly political purpose.

*airbrushing_*The airbrush was invented in the late nineteenth century, but it was not until the mid-twentieth century that it became a popular tool in painting. It is a small, hand-held instrument connected to a canister of compressed air that sprays paint in a controlled way. Pioneers of airbrushing were the graphic illustrators George Petty and Alberto Vargas (or Varga) in the 1930s and 1940s. Later, Pop artist James Rosenquist used it to evoke the qualities of advertising. In Britain, the artist Barrie Cook became one of the leading practitioners to use airbrushing. Today, it is the

sci-fi artist H.K. Giger who is most commonly associated with the medium. There is also an airbrushing computer program, invented in the early 1980s, which creates a similar effect in a digital format.

*AkhRR*_The Association of Artists of Revolutionary Russia, founded in Moscow in 1922, depicted everyday life among the working people of Russia after the Bolshevik Revolution in a realistic, documentary manner. Opposed to the non-realist innovations of the avant-garde, the association quickly became the most influential artistic group in Soviet Russia. In 1928 it was renamed the Association of Artists of the Revolution (AkhR) and in the following year established the journal *Art of the Masses*. Though abolished in 1932, the association was an influential precursor of Socialist Realism.

*alabaster*_A fine-grained marble-like variety of gypsum, alabaster is a soft stone often white or translucent.

*allegory*_In art, a composition in which all the elements are designed to symbolise or illustrate some general idea such as life, death, love, virtue, faith, justice and prudence.

*Altermodern*_Coined by curator Nicolas Bourriaud on the occasion of the Tate Triennial 2009, Altermodern is an in-progress redefinition of modernity in the era of globalisation, which focuses on cultural translations and time-space crossings. Against cultural standardisation and massification but also opposed to nationalisms and cultural relativism, Altermodern artists position themselves within the world's cultural gaps. Cultural translation, mental nomadism and format crossing are the main principles of Altermodern art. Viewing time as a multiplicity rather than as a linear progress, the Altermodern artist navigates history as well as all the

planetary time zones producing links between signs far away from each other. Altermodern is 'docufictional' in that it explores the past and the present to create original paths where boundaries between fiction and documentary are blurred. Formally speaking, it favours processes and dynamic forms to one-dimensional single objects and trajectories to static masses.

American Abstract Artists (AAA)_
An organisation founded in 1936 to promote the appreciation of abstract art in the United States. It held its first annual exhibition in April 1937. Early members included Josef Albers, Willem de Kooning, Lee Krasner, Jackson Pollock and David Smith.

American Social Realist photography_During
America's Great Depression of the 1930s and 1940s, photographers were employed by the Farm Security Administration (FSA) to document the rural poverty and exploitation of sharecroppers and migrant labourers in an attempt to garner support for President Franklin D. Roosevelt's New Deal. The photographs were distributed free of charge to newspapers across the country and brought the plight of displaced farming communities to the public's attention. The most famous images were made by Dorothea Lange and Walker Evans, whose black and white stills of starving fruit-pickers in California became iconic symbols of the Great Depression.
(See also Social Realism)

Analytical Cubism_In an attempt to classify
the revolutionary experiments made by Pablo Picasso, Georges Braque and Juan Gris when they were exponents of Cubism, historians have tended to divide Cubism into two stages. The early phase, generally considered to run from 1908 to 1912, is called Analytical Cubism and the second is called

Synthetic Cubism. Analytical Cubism was so-called because of its structured dissection of the subject, viewpoint-by-viewpoint, resulting in a fragmentary image of multiple viewpoints and overlapping planes. Other distinguishing features of Analytical Cubism were a simplified palette of colours, so the viewer was not distracted from the structure of the form, and the density of the image at the centre of the canvas.

*Angry Penguins*_Title of Australian modernist literary journal founded in 1940 at the University of Adelaide by four poets: D.B. Kerr, M.H. Harris, P.G. Pfeiffer and G. Dutton. At this time the University of Adelaide was a focus of modernist writing and debate under the influence of the poet, playwright and teacher C.R. Jury, who acted as patron to the magazine. The name became that of the modernist literary and artistic movement, centred around Harris, that sought to shake up the entrenched cultural establishment of Australia in the 1940s. They were seen as 'angry' young men – the rebels of their day. The Angry Penguins represented the new language and the new painting of Australia. They were forthright and unapologetic, demanding to be heard and seen. The artists included Arthur Boyd, Sidney Nolan and Albert Tucker. In 1944 *Angry Penguins* was the victim of a famous literary hoax when two opponents concocted a set of modernist poems by a writer they invented called 'Ern Malley'. Harris published them and a storm ensued when the hoax was revealed. Harris was tried and convicted for publishing obscenities and the cause of modernism in Australia was substantially set back.

*animation*_Animation is the rapid display of sequences of static imagery in such a way as to create the illusion of movement. The history of animation dates back to early Chinese shadow lanterns and the optical toys of the eighteenth century, but it was

not until the beginning of the twentieth century that illustrators like Émile Cohl began drawing cartoon strips on to celluloid. The most famous animator was Walt Disney, best known for his cartoon feature films like *Fantasia* and *The Jungle Book* and whom Salvador Dalí believed to be the heir to <u>Surrealism</u>. Computer animation began in the 1960s and is animation's digital successor. Using software programs like Adobe Flash, animators build up sequences on a computer to be used as special effects in film, called Computer Generated Imagery (CGI), or as animated sequences in their own right. Computer animation has distinct advantages for artists: it is cheap to make, fast, and the artist is able to control every aspect of the process, unlike the vagaries of shooting film which cannot be viewed until developed. Sites like YouTube and MySpace have become forums for computer animation, bypassing the traditional galleries and museums as the spaces for artistic enterprise.

*anthropophagia_*Meaning cannibalism, as an art term it is associated with the 1960s Brazilian art movement Tropicália. Artists Hélio Oiticica, Lygia Clark, Rogério Duarte and Antonio Dias used anthropophagia in the sense of a cultural and musical cannibalism of other societies. Embracing the writings of the poet Oswald de Andrade (1890–1954), who wrote the *Manifesto Antropófago* (Cannibal Manifesto) in 1928, they argued that Brazil's history of cannibalising other cultures was its greatest strength and had been the nation's way of asserting independence over European colonial culture. The term also alluded to cannibalism as a tribal rite that was once practised in Brazil. The artworks made as a result of this concept stole their influences from Europe and America but, ultimately, were rooted in the cultural and political world of 1960s and 1970s Brazil.

*anti-art*_Refers to art that challenges the existing accepted definitions of art. It is generally agreed to have been coined by Marcel Duchamp around 1913 when he made his first readymades, which are still regarded in some quarters as anti-art (for example by the Stuckist group). In 1917 Duchamp submitted a urinal, titled *Fountain*, for an exhibition in New York, which subsequently became notorious and eventually highly influential. Anti-art is associated with Dada, the artistic and literary movement founded in Zurich in 1916 and simultaneously in New York, in which Duchamp was a central figure. Since Dada there have been many art movements that have taken a position on anti-art, from the low-fi mail art movement to the YBAs, some of whom have embraced the absurdities of Dada and Duchamp's love of irony, paradox and punning.

*appropriation*_As a term in art history and criticism, this refers to the taking over, into a work of art, of a real object or even an existing work of art. The practice can be tracked back to the Cubist constructions and collages of Pablo Picasso and Georges Braque made from 1912 onwards, in which real objects, such as newspapers, were included to represent themselves. Appropriation was developed much further in the readymades created by the French Dada artist Marcel Duchamp from 1913. Most notorious of these was *Fountain*, a men's urinal signed, titled and presented on a pedestal. Later, Surrealism also made extensive use of appropriation in collages and objects, such as Salvador Dalí's *Lobster Telephone*. In the late 1950s appropriated images and objects appear extensively in the work of Jasper Johns and Robert Rauschenberg, and in Pop art. However, the term seems to have come into use specifically in relation to certain American artists in the 1980s, notably Sherrie Levine and the artists of the Neo-Geo group, particularly Jeff Koons. Sherrie Levine reproduced other works of art as her own work, including paintings by Claude Monet and Kasimir

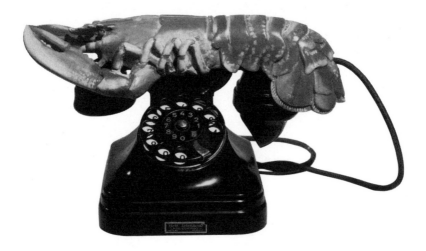

Malevich. Her aim was to create a new situation, and therefore a new meaning or set of meanings, for a familiar image. Appropriation art raises questions of originality, authenticity and authorship, and belongs to the long <u>modernist</u> tradition of art that questions the nature or definition of art itself. Appropriation artists were influenced by the 1936 essay by the German philosopher Walter Benjamin, 'The Work of Art in the Age of Mechanical Reproduction', and received contemporary support from the American critic Rosalind Krauss in her 1985 book *The Originality of the Avant-Garde and Other Modernist Myths*. Appropriation has been used extensively by artists since the 1980s.

appropriation
Salvador Dalí
Lobster Telephone 1936
Plastic, painted plaster
and mixed media
17.8 x 33 x 17.8
Tate. Purchased 1981

*aquatint*_An <u>intaglio</u> printmaking technique, used to create <u>tonal</u> effects rather than lines. Fine particles of acid-resistant material, such as powdered rosin, are attached to a printing plate by heating. The plate is then immersed in an acid bath, just like <u>etching</u>. The acid eats into the metal around the particles to produce a granular pattern of tiny indented rings. These hold sufficient <u>ink</u> to give the effect of an area of wash when

inked and printed. The extent of the printed areas can be controlled by varnishing those parts of the plate to appear white in the final design. Gradations of tone can be achieved by varying the length of time in the acid bath; longer periods produce more deeply bitten rings, which print darker areas of tone. The technique was developed in France in the 1760s, and became popular in Britain in the late eighteenth and early nineteenth centuries. It is often used in combination with other intaglio techniques.

*archive*_Traditionally an archive is a store of documents or artefacts of a purely documentary nature. The rise of Performance art in the twentieth century meant that artists became heavily reliant on documentation as a record of their work. A similar problem arose in relation to the Land art movement of the 1960s whose interventions in the landscape were often eradicated by the elements. Conceptual art often consisted of documentation. In practice the documentation – photograph, video, map, text – was rapidly adapted to have the status of artwork. Some artists have used the actual structure of the archive for their work. In 1999 Mark Dion sifted the silt beds of the Thames and displayed the contents in mahogany cabinets at Tate Britain, London. Over six years Jeremy Deller, together with Alan Kane, collated his epic Folk Archive, which documents popular culture around the United Kingdom and Ireland.

*Art & Language*_A pioneering Conceptual art group founded in Coventry, England, in 1968. The four founder members were Michael Baldwin, David Bainbridge, Terry Atkinson and Harold Hurrell. The critic and art historian Charles Harrison and the artist Mel Ramsden both became associated in 1970. In *A Provisional History of Art & Language*, Charles Harrison and Fred Orton recorded that between 1968 and 1982, up to fifty people

were associated in some way with the activities around the name Art & Language and they identified three main phases of the group: the early years, up to 1972, which chiefly found public expression in the publication *Art-Language*; a middle period divided between New York and England and linked to the publication of the journal *The Fox* (discontinued in 1976); and the period since 1977, during which paintings have been produced. In that period, Art & Language has mainly concerned three people, the artists Michael Baldwin and Mel Ramsden, and the critic Charles Harrison. From the beginning, Art & Language questioned the critical assumptions of mainstream modern art practice and criticism. Much of their early work consisted of detailed discussion of these issues, presented in their journal or in an art gallery context. However, they also made exemplary works of Conceptual art such as *Map Not to Indicate* of 1967. The paintings they have made since 1977 examine the critical issues that concern them through the actual practice of painting. For a more detailed account of Art & Language see the full catalogue text for the work *Gustave Courbet's 'Burial at Ornans'; Expressing a Sensuous Affection .../Expressing a Vibrant Erotic Vision .../Expressing States of Mind that are Vivid and Compelling.*

*Art Brut*_French term translating as 'raw art', which was invented by the French artist Jean Dubuffet to describe art made outside the tradition of fine art, dominated by academic training, which he referred to as *art culturel* (cultural art). Art Brut included graffiti, the work of patients in psychiatric hospitals, prisoners, children, and naïve or primitive artists. What Dubuffet valued in this material was the raw expression of a vision or emotions, untrammelled by convention. These qualities he attempted to incorporate into his own art, to which the term Art Brut is also sometimes applied. Dubuffet made a large collection of Art Brut, and in

1948 founded the Compagnie de l'Art Brut to promote its study. His collection is now housed in a museum, La Collection de l'Art Brut in the Swiss city of Lausanne. Another major collection, using the term outsider art, is the Musgrave Kinley Outsider Art Collection, now on loan to the Irish Museum of Modern Art, Dublin.

*Art Deco*_Design style of the 1920s and 1930s in furniture, pottery, textiles, jewellery, glass, etc. It was also a notable style of cinema and hotel architecture. Named after the International Exhibition of Modern Decorative and Industrial Arts held in Paris in 1925, it can be seen as successor to and a reaction against Art Nouveau. The chief difference from Art Nouveau is the influence of Cubism, giving Art Deco design generally a more fragmented, geometric character. However, imagery based on plant forms and sinuous curves remained in some Art Deco design, for example that of Clarice Cliff in Britain. Art Deco was in fact highly varied, showing influences from ancient Egyptian art, Aztec and other ancient Central American art, and the design of modern ships, trains and motor cars. Art Deco also drew on the modern architecture and design of the Bauhaus, and of architects such as Le Corbusier and Mies van de Rohe.

*Art Informel*_French term describing a wide swathe of related types of abstract painting highly prevalent, even dominant, in the 1940s and 1950s, including tendencies such as Tachisme, matter painting and Lyrical Abstraction. It mainly refers to European art, but embraces American Abstract Expressionism. The term was used by the French critic Michel Tapié in his 1952 book *Un Art Autre* to describe types of art that were based on highly improvisatory (i.e. informal) procedures and were often highly gestural. Tapié saw this art as 'other' because it appeared to him as a complete break with tradition. An important source of this kind of

painting was the <u>Surrealist</u> doctrine of <u>Automatism</u>. An exhibition titled *Un Art Autre* was organised in Paris the same year as Tapié's book and included Karel Appel, Alberto Burri, Willem De Kooning, Jean Dubuffet, Jean Fautrier, Jean-Paul Riopelle and Wols. Other key figures were Henri Michaux, Hans Hartung and Pierre Soulages. The term 'Art Autre', from the title of Tapié's book, is also used for this art, but Art Informel seems to have emerged as the preferred name.

*Art Nouveau*_Complex international style in architecture and design, parallel to <u>symbolism</u> in fine art. It developed through the 1890s and was brought to a wide audience by the 1900 *Exposition Universelle* in Paris. The style was characterised by sinuous linearity and flowing organic shapes based on plant forms. In Britain, Charles Rennie Mackintosh contained these qualities within severe but eccentric geometry. Art Nouveau was exemplified by the Paris Metro station entrances by Hector Guimard, Tiffany glass, Mackintosh's chairs and his Glasgow School of Art, and book designs of Aubrey Beardsley, Charles Ricketts and followers such as Arthur Rackham. The style flourished until it was killed off by the First World War.

*Art Workers' Coalition (AWC)*_A group of activists, including Carl Andre, Lucy Lippard and Robert Smithson, who came together in 1969, in New York, to promote artists' rights and to challenge the art establishment to take political positions against discrimination and inequality.

*Arte Nucleare*_Refers to the work of the Movimento d'Arte Nucleare, founded by the Italian artist Enrico Baj, together with Sergio Dangelo and Gianni Bertini, in Milan in 1951. Gianni Dova was a later member. Their first manifesto was issued the following year and another in 1959. The name might be translated as 'art for

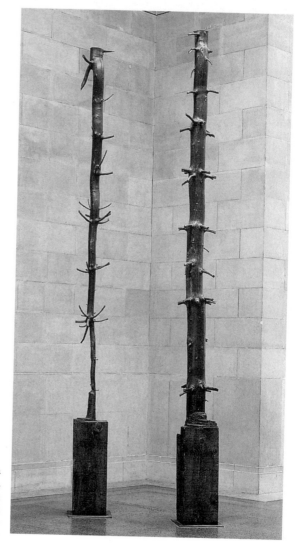

Arte Povera

Giuseppe Penone
Tree of 12 Metres 1980–2
American larchwood
600 x 50 x 50
Tate. Purchased 1989

the nuclear age', since the group specifically set out to make art in relation to this. Their manifestos warned of the dangers of the misapplication of nuclear technology. They declared opposition to geometric abstract art and proposed instead the use of automatic techniques; they were thus closely aligned with Art Informel. In the early 1950s Baj was making paintings with suggestions of mushroom clouds and devastated landscapes. In his later painting and collage works he gave the name 'heavy water' to the enamel paint and distilled water emulsion he used. Several exhibitions were held but the movement petered out around 1960.

*Arte Povera*_A term introduced by the Italian art critic and curator, Germano Celant, in 1967. His pioneering texts and a series of key exhibitions provided a collective identity for a number of young Italian artists based in Turin, Milan, Genoa and Rome. Arte Povera emerged from within a network of urban cultural activity in these cities, as the Italian economic miracle of the immediate post-war years collapsed into a chaos of economic and political instability. The name means literally 'poor art' but the word poor here refers to the movement's signature exploration of a wide range of materials beyond the quasi-precious traditional ones of oil paint on canvas, or bronze, or carved marble. Arte Povera therefore denotes not an impoverished art, but an art made without restraints, a laboratory situation in which any theoretical basis was rejected in favour of a complete openness towards materials and processes. Leading artists were Giovanni Anselmo, Alighiero Boetti, Pier Paolo Calzolari, Luciano Fabro, Piero Gilardi, Jannis Kounellis, Mario Merz, Marisa Merz, Giulio Paolini, Pino Pascali, Giuseppe Penone, Michelangelo Pistoletto, Emilio Prini and Gilberto Zorio. The heyday of the movement was 1967–72, but its influence on later art has been enduring. It can also be seen as the Italian contribution to Conceptual art.

Artists International Association (AIA)_

An exhibiting society founded in London in 1933 and active until 1971. It was principally a left-of-centre political organisation and it embraced all styles of art both <u>modernist</u> and traditional. Its aim was the 'Unity of Artists for Peace, Democracy and Cultural Development'. It held a series of large group exhibitions on political and social themes, beginning in 1935 with the exhibition *Artists Against Fascism and War*. The AIA supported the left-wing Republican side in the Spanish Civil War (1936–9) through exhibitions and other fund-raising activities. It tried to promote wider access to art through travelling exhibitions and public <u>mural</u> paintings. In 1940 it published a series of art <u>lithographs</u> titled *Everyman Prints* in large and therefore cheap <u>editions</u>.

Arts and Crafts Movement_

Movement in design emerging from the Pre-Raphaelite circle and initiated by William Morris in 1861 when he founded his design firm Morris & Co. in London. He recruited Dante Gabriel Rossetti, Ford Madox Brown and Edward Burne-Jones as artist-designers and their key principle was to raise design to the level of art. They also tried to make good design available to the widest possible audience. The Arts and Crafts Movement was seen as leading to modern design, for example by Nikolaus Pevsner in *Pioneers of Modern Design: William Morris to Walter Gropius,* first published in 1936. Morris emphasised simple functional design without the excess ornament and imitation of the past, which was typical of Victorian styles. Wallpapers and fabrics were based on natural motifs, particularly plant forms, and treated as flat pattern. A key influence on the <u>Aesthetic Movement</u> and <u>Art Nouveau</u> as well as later modern design.

*Ashcan School_*A group of North American artists who used <u>realist</u> techniques to depict social deprivation and injustice in the American urban environment of the early twentieth century. Artists included Robert Henri, regarded as the founder of the Ashcan School, and John Sloan.

*assemblage_*Art made by assembling disparate elements often scavenged by the artist (see <u>found object</u>), sometimes bought specially. The practice goes back to Pablo Picasso's <u>Cubist</u> constructions, the three-dimensional works he began to make from 1912. An early example is his *Still Life* 1914, which is made from scraps of wood and a length of tablecloth fringing, glued together and painted. Picasso himself remained an intermittent practitioner of assemblage. It was the basis of <u>Surrealist</u> objects, became widespread in the 1950s and 1960s and continues to be extensively used, for example by the <u>YBAs</u>.

*atelier_*A literal translation of the French word *atelier* is studio or workshop. The individual artist's studio was also a place where the teaching of young artists took place but this function was gradually supplanted by the rise of the <u>academy</u>. At the beginning of the twentieth century, some ateliers developed into places of communal production, particularly in Germany, where there emerged a desire to unify art with industrial production. In 1919 Walter Gropius founded the <u>Bauhaus</u> in an attempt to marry the arts with the technology of the mechanical age. Atelier often denotes a group of artists, designers or architects working collectively. Atelier 5 is a Swiss architectural firm founded in 1955 and inspired by the visions of Le Corbusier; the Rotterdam-based Atelier Van Lieshout, founded by Joep van Lieshout, is a group of artists who devise alternative modes of living and working.

*attribute_*This term has different meanings as a noun and a verb. In art an attribute (noun) is an object or animal associated with a particular personage. The most common attributes are those of the ancient Greek gods. For example doves are attributes of the goddess of love, Aphrodite or Venus. So a female nude with a dove or doves may be identified as Venus. The ancient musical instrument known as a lyre is an attribute of Apollo, god of music and the arts. A bow and arrows and/or a spear, together with hounds, are attributes of the goddess Diana, who was famous as a huntress. She was also goddess of the moon, so often has a crescent in her hair. To attribute (verb) a work of art is to suggest that it may be by a particular artist, although there is no hard evidence for that.

*aura_*The term used by Walter Benjamin in his influential 1936 essay 'The Work of Art in the Age of Mechanical Reproduction', where it is identified as a quality integral to an artwork that cannot be communicated through mechanical reproduction, such as photography.

*auto-destructive art_*Term invented by the artist Gustav Metzger in the early 1960s and put into circulation by his article 'Machine, Auto-creative and Auto-destructive Art' in the summer 1962 issue of the journal *Ark*. From 1959 he had made work by spraying acid on to sheets of nylon as a protest against nuclear weapons. The procedure produced rapidly changing shapes before the nylon was all consumed, so the work was simultaneously auto-creative and auto-destructive. In 1966 Metzger and others organised the 'Destruction in Art Symposium' in London. This was followed by another in New York in 1968. The Symposium was accompanied by public demonstrations of auto-destructive art including the burning of *Skoob Towers* by John Latham. These were towers of books (skoob

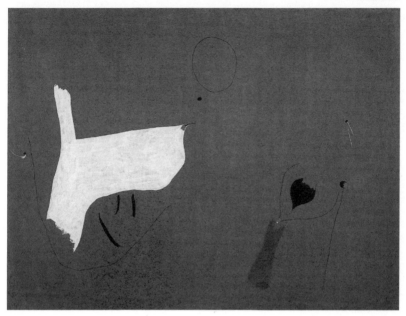

is books in reverse) and Latham's intention was to demonstrate directly his view that Western culture was burned out. In 1960 the Swiss artist Jean Tinguely made the first of his self-destructive machine sculptures, *Hommage à New York*, which battered itself to pieces in the Sculpture Garden of the Museum of Modern Art, New York.

*Automatism_*The central method of Surrealism, this movement was launched by the French poet André Breton in the *Manifesto of Surrealism* published in Paris in 1924. He was strongly influenced by the ideas of Sigmund Freud, the founder of psychoanalysis. Automatism is the same as free association, the method used by Freud to explore the unconscious mind of his patients. In the manifesto, Breton actually defined Surrealism as 'Pure psychic automatism ... the dictation of thought in the absence of all control exercised by reason and outside all moral or aesthetic concerns'. The aim was to access material from the unconscious

Automatism
Joan Miró
Painting 1927
Tempera and oil on canvas
97.2 x 130.2
Tate. Purchased with assistance from the Friends of the Tate Gallery 1971

mind. The earliest examples are the automatic writings of Breton and others, produced by simply writing down as rapidly as possible whatever springs to mind. Surrealist collage, invented by Max Ernst, was the first form of visual Automatism, in which he put together images clipped from magazines, product catalogues, book illustrations, advertisements and other sources to create a strange new reality. In painting various forms of Automatism were then developed by artists such as Joan Miró, André Masson and Max Ernst. Later it led to the Abstract Expressionism of Jackson Pollock and others and was an important element in the European movements of Art Informel and Arte Nucleare.

*avant-garde*_Originally a French term, meaning vanguard or advance guard (the part of an army that goes forward ahead of the rest). Applied to art, it means that which is in the forefront, is innovatory, which introduces and explores new forms and in some cases new subject matter. In this sense the term first appeared in France in the first half of the nineteenth century and is usually credited to the influential thinker Henri de Saint-Simon, one of the forerunners of socialism. He believed in the social power of the arts and saw artists, alongside scientists and industrialists, as the leaders of a new society. In 1825 in his book *Opinions littéraires, philosophiques et industrielles* he wrote: 'We artists will serve you as an avant-garde ... the power of the arts is most immediate: when we want to spread new ideas we inscribe them on marble or canvas ... What a magnificent destiny for the arts is that of exercising a positive power over society, a true priestly function and of marching in the van [i.e. vanguard] of all the intellectual faculties!' Avant-garde art can be said to begin in the 1850s with the Realism of Gustave Courbet, who was strongly influenced by early socialist ideas. This was followed by the successive movements of modern art, and the term avant-garde is more or

less synonymous with modern. Some avant-garde movements, for example Cubism, have focused mainly on innovations of form; others, such as Futurism, De Stijl or Surrealism, have had strong social programmes. The notion of the avant-garde enshrines the idea that art should be judged primarily on the quality and originality of the artist's vision and ideas.

*AWC*_see Art Workers' Coalition

*Bauhaus_*Revolutionary school of art, architecture and design established by the pioneer modern architect Walter Gropius at Weimar, Germany in 1919. Its teaching method replaced the traditional pupil-teacher relationship with the idea of a community of artists working together. Its aim was to bring art back into contact with everyday life, and design was therefore given as much weight as fine art. The name is a combination of the German words for building (*bau*) and house (*haus*) and may have been intended to evoke the idea of a guild or fraternity working to build a new society. The Bauhaus moved to Dessau in 1925–6 where Gropius created a new building for it. In 1932 it moved to Berlin where it was closed by the Nazis. Teachers included Wassily Kandinsky, Paul Klee, Laszlo Moholy-Nagy and Josef Albers. Its influence was immense, especially in the USA where Moholy-Nagy opened the New Bauhaus in Chicago in 1937. In 1933 Albers took its methods to Black Mountain College in North Carolina and in 1950 to Yale University.

*biennial_*In the art context biennial has come to mean a large international exhibition held every two years. The first was the Venice Biennale in 1895, which was situated in the Giardini, a public park, and now houses thirty permanent national pavilions and many smaller temporary structures. The early years were dominated by European art, but the exhibition now includes contributions from countries in South America, Africa, Asia and the Middle East. The late twentieth century saw a dramatic increase in biennials and by 2007 there were some fifty across the world, including the Beijing Biennial, the Liverpool Biennial, the Prague Biennale, the São Paulo Biennal and the Sharjah Biennial in The Gulf. This explosion of large-scale international art exhibitions mirrors the financial boom in international art buying.

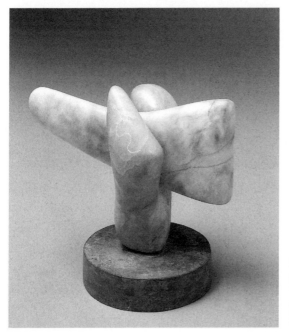

biomorphic
Dame Barbara Hepworth
Two Forms 1933
Alabaster and limestone
26 x 29.6 x 17.6, 7 kg
Tate. Purchased 1996

*bio art*_Bio art uses biotechnology as its medium.
The creations of bio art become part of evolution and,
provided they are capable of reproduction, can last
as long as life exists on earth. They raise questions
about the future of life, evolution, society and art.
Currently the dominant aspect of bio art is genetic art,
as represented by the Brazilian-born artist Eduardo Kac,
who genetically engineered a green fluorescent rabbit in
2000. As scientists continue their pioneering work into
biotechnology, artists are also experimenting with cell
and tissue cultures and neurophysiology. An example
of this is the Australian-based duo Oron Catts and Ionat
Zurr who have attempted to grow a quarter-scale replica
of an artist's ear.

*biomorphic*_In painting and sculpture biomorphic
forms or images are ones that, while abstract,
nevertheless refer to, or evoke, living forms such as
plants and the human body. The term comes from

combining the Greek words *bios* (life) and *morphe* (form). Biomorphic seems to have come into use around the 1930s to describe the imagery in the more abstract types of <u>Surrealist</u> painting and sculpture, particularly in the work of Joan Miró and Jean Arp (see <u>Automatism</u>). Henry Moore and Barbara Hepworth also produced some superb biomorphs at that time and, later, so did Louise Bourgeois.

*Black Mountain College*_Highly influential college founded at Black Mountain, North Carolina, USA, in 1933. Its progressive principles were based on the educational theories of John Rice, its founder. Drama, music and fine art were given equal status in the curriculum to all other academic subjects. Teaching was informal and stress was laid on communal living and outdoor activities. Most of the work of running the college and maintaining the buildings was done by students and faculty. Among its first teachers of art was Josef Albers, who had fled Nazi Germany after the closure of the <u>Bauhaus</u> that same year. Black Mountain quickly became an extraordinary powerhouse of modern culture in America. Its board of advisers included Albert Einstein and among its teachers at one time or another were some of the greatest luminaries of modern American culture including the founder of the Bauhaus, the architect Walter Gropius, the <u>Abstract Expressionist</u> painters Willem de Kooning and Robert Motherwell, the composer John Cage and the dancer Merce Cunningham. In 1949 Albers and others left as a result of internal divisions. The college was reconstituted under the poet Charles Olson but eventually closed in 1953. Among its most notable artist students were Kenneth Noland and Robert Rauschenberg.

*Der Blaue Reiter*_German <u>Expressionist</u> group. In English, The Blue Rider. It originated in 1909 in Munich, where the <u>Neue Künstlervereinigung</u>, or New

Artists' Association (NKV), was founded by a number of avant-garde artists. The most important of these were the Russian-born Wassily Kandinsky and the German, Franz Marc. In 1911 Kandinsky and Marc broke with the rest of the NKV and in December that year held in Munich the first exhibition of Der Blaue Reiter. This was an informal association rather than a coherent group like Die Brücke. Other artists closely involved were Paul Klee and August Macke. In 1912 Marc and Kandinsky published a collection of essays on art with a woodcut cover by Kandinsky. This was the *Almanach Der Blaue Reiter*. Why the name was chosen is not entirely clear. Franz Marc adored horses and his many paintings of them and other animals is symptomatic of the turning back to nature (an aspect of primitivism) of many early modern artists. Kandinsky had apparently always been fascinated by riders on horseback (horses are symbols of power, freedom and pleasure). A Kandinsky painting of 1903 is actually called *The Blue Rider*. Blue is a colour that has often seemed of special importance to artists and for Kandinsky and Marc, whose favourite colour it was, it seems to have had a mystical significance. Der Blaue Reiter was brought to an end by the First World War in which both Macke and Marc were killed.

*Bloomsbury_*A district of quiet squares near central London. Its name is commonly used to identify a circle of intellectuals and artists who lived there in the period 1904–40. The intellectuals included the biographer Lytton Strachey, the economist John Maynard Keynes, the novelist Virginia Woolf and the art critic Clive Bell. The principal artists were Vanessa Bell, Roger Fry, who was also a highly influential critic, and Duncan Grant. Bloomsbury was in revolt against everything Victorian and played a key role in introducing many modern ideas into Britain. In 1910 Fry organised the London exhibition *Manet and the Post-Impressionists*, which brought modern French art to the attention

of the British public. Visitors to the show were duly scandalised by the many works by Paul Cézanne, Paul Gauguin, Vincent van Gogh, Henri Matisse and Pablo Picasso. The Bloomsbury painters created their own distinctive brand of Post-Impressionism and around 1914 experimented with abstract art. Fry also founded the design firm Omega Workshops for which the Bloomsbury artists designed pottery, furniture, fabrics and interiors. Note that Bloomsbury resisted being categorised as a group.

*body art*_Used to describe art in which the body, often that of the artist, is the principal medium and focus. It covers a wide range of art from about 1960 onwards, encompassing a variety of approaches. It includes much Performance art, where the artist is directly concerned with the body in the form of improvised or choreographed actions, happenings and staged events. However, the term body art is also used for explorations of the body in a variety of other media including painting, sculpture, photography, film and video. Body art has frequently been concerned with issues of gender and personal identity. A major theme has been the relationship of body and mind, explored in work consisting of feats of physical endurance designed to test the limits of the body and the ability of the mind to suffer pain. Body art has often highlighted the visceral or abject aspects of the body, focusing on bodily substances or the theme of nourishment. It has also highlighted contrasts such as those between clothed and nude, internal and external, parts of the body and the whole. In some work, the body is seen as the vehicle for language. In 1998 the art historian Amelia Jones published a survey titled *Body Art*.
(See also Conceptual art; feminist art)

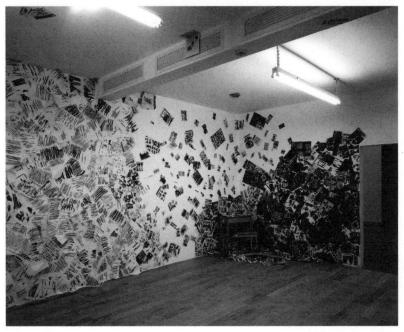

*bricolage*_The best translation of the French word *bricolage* is do-it-yourself and the creative core of bricolage in an art context is an ability to make art out of any materials that come to hand. This approach became popular in the early twentieth century when resources were scarce and aspects of <u>Surrealism</u>, <u>Dada</u> and <u>Cubism</u> have a bricolage character. But it was not until the early 1960s, with the formation of the Italian movement <u>Arte Povera</u>, that bricolage took on a political aspect and it was used by artists to bypass the commercialism of the art world. Arte Povera artists constructed <u>sculptures</u> out of rubbish in an attempt to devalue the art object and assert the value of the ordinary and everyday. Since then, artists have continued to make art out of detritus; Tomoko Takahashi constructs vast sculptures of junk found on the streets as a comment on the disposable nature of our culture and society.

bricolage
Tomoko Takahashi
Drawing Room 1998
Mixed media
Presented by the Patrons of New Art
(Special Purchase Fund) 2002

*browser art*_Browser art is a sub-genre of net art and relates specifically to a renegade artwork made as part of a URL that uses the computer as raw material, transforming the codes, the structure of the websites and the links between servers into visual material. Some browser artworks automatically connect to the Internet and then proceed to mangle the web pages by reading the computer's 'code' the wrong way. The duo Joan Hermskerk and Dirk Paesmans, known as Jodi, have devised a program which the net art writer Tilman Baumgärtel has described as transforming a PC 'into an unpredictable, terrifying machine that seems to have a life of its own'. Other artists, like the British-based duo Tom Corby and Gavin Baily, reduce image-rich web pages to stark white text and the American artist Maciej Wisniewski has developed a browser that transforms the interactive experience of surfing the net into a passive activity, staring at floating images and texts.
(See also software art)

*Die Brücke*_German Expressionist group founded in Dresden in 1905. The name means bridge and may have been intended to convey the idea of a bridge between the artist, seen as a special person, and society at large. Also, Die Brücke recruited members who were not artists but patrons, paying a subscription entitling them to an annual portfolio of prints. The name may thus refer to this direct bridge between artist and patron. The manifesto of 1906 stated 'we want to achieve freedom of life and action against the well established older forces'. In art this freedom involved blending elements of old German art and African and South Pacific tribal art with Post-Impressionism and Fauvism to create a distinctive modern style. In life they sought a return to a more direct relationship with nature (another bridge). This is vividly expressed in their pictures of themselves bathing nude in the lakes near Dresden. Chief artists were Ernst Ludwig Kirchner, Karl Schmidt-Rottluff, Fritz

Bleyl and Erich Heckel, joined in 1910 by Otto Müller.
Emil Nolde was also briefly a member.

*brushwork*_A word used in relation to painting
to describe the characteristics of the paint surface
resulting from its application with a brush. Brushwork
can range from extremely smooth – as, for example,
in the work of the German Neue Sachlichkeit painters
– to extremely thick, as in the various forms of
Expressionism, and what is called gestural (see also
impasto). Brushwork, like handwriting, can be highly
individual and can be an important factor in identifying
an artist's work. It can also be highly expressive – that
is, the application of the paint itself plays a role in
conveying the emotion or meaning of the work. In
modern art theory, emphasis is placed on the idea
that a painting should have its own reality rather than
attempting to imitate the three-dimensional world.
Value is therefore placed on distinctive brushwork
because it asserts the two-dimensional surface of the
work and the reality of the paint itself. Distinctive
brushwork is also seen as valuable because it
foregrounds the role of the medium itself. The painter
Robert Ryman has devoted his entire career to an
exploration of brushwork.

*Brutalism*_Coined by the British architectural critic
Reyner Banham to describe the approach to building
particularly associated with the architects Peter and
Alison Smithson in the 1950s and 1960s. The term
originates from the use by the pioneer modern architect
and painter Le Corbusier of *beton brut* (raw concrete).
Banham gave the French word a punning twist to
express the general horror with which this concrete
architecture was greeted in Britain. Typical examples
of Brutalism are the Hayward Gallery and National
Theatre on London's South Bank. The term Brutalism
has sometimes been used to describe the work of artists
influenced by Art Brut.

cadavre exquis (exquisite corpse)_ Invented in 1925 in Paris by the Surrealists Yves Tanguy, Jacques Prévert, André Breton and Marcel Duchamp, cadavre exquis is similar to the old parlour game consequences, in which players write in turn on a sheet of paper, fold to conceal part of the writing and pass it on to the next player. The Surrealists adapted the game by drawing parts of the body. The name cadavre exquis was derived from a phrase that resulted when they first played the game, 'Le cadavre/ exquis/ boira/ le vin/ nouveau' ('The exquisite corpse will drink the new wine').

Camden Town Group_ British Post-Impressionist group founded by Walter Sickert in London in 1911. Other members were Robert Bevan, Spencer Gore, Harold Gilman and Charles Ginner. They painted realist scenes of city life and some landscape in a range of Post-Impressionist styles. The group was named after the seedy district of north London where Sickert had lived in the 1890s and again from 1907. His series of Camden Town nudes and his paintings of alienated couples in interiors, such as *Ennui*, are his outstanding contribution to Camden Town art.

canvas_ Strong, woven cloth traditionally used for artists' supports. Commonly made of either linen or cotton thread, but also manufactured from man-made materials such as polyester.

caricature_ A caricature is a painting, or more usually drawing, of a person or thing in which the features and form have been distorted and exaggerated in order to mock or satirise the subject.

carving_ see direct carving; sculpture

cast_ A form created by pouring liquid material, such as plaster or molten metal, into a mould.

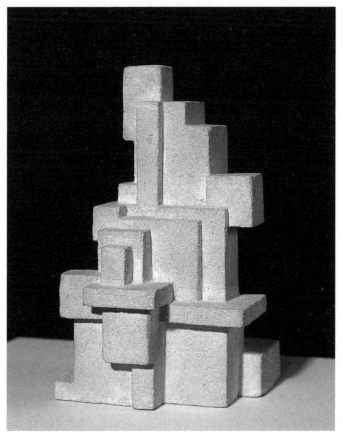

*Cercle et Carré (Circle and Square)*_French abstract group founded in Paris in 1929 by critic and artist Michel Seuphor and artist Joaquín Torres García. They published a periodical of the same name and held a major group exhibition in 1930. This included 130 works by a wide range of abstract artists. The group strongly supported new developments in abstract art and in particular promoted the mystical tendency within it. Cercle et Carré was absorbed by Abstraction-Création when the latter was founded in 1931, but Torres García continued the publication in Montevideo in his native Uruguay.

Cercle et Carré
Georges Vantongerloo
Interrelation of Volumes 1919
Sandstone
22.5 x 13.7 x 13.7
Tate. Purchased 1978

*chalk_*White or off-white inorganic material composed of calcium carbonate. Naturally occurring, although also produced industrially throughout the twentieth century.

*charcoal_*One of the most basic drawing materials, known since antiquity. It is usually made of thin peeled willow twigs that are heated without the presence of oxygen. This produces black crumbly sticks, which leave microscopic sharp-edged particles in the paper or textile fibres, producing a line denser at the pressure point, but more diffuse at the edges. The overall result is less precise than hard graphite pencils, suited to freer studies. Charcoal smudges easily and is often protected with a sprayed fixative. It is used to make both sketches and finished works, and as under-drawing for paintings. In the twentieth century a processed version was developed, called compressed charcoal.

*chiaroscuro_*Italian term used in that form in English. It translates as light-dark, and refers to the balance and pattern of light and shade in a painting or drawing. Chiaroscuro is generally only remarked upon when it is a particularly prominent feature of the work, usually when the artist is using extreme contrasts of light and shade.

*CoBrA_*Group formed in 1948 by artists from Copenhagen, Brussels and Amsterdam and taking its name from the first letters of those cities. However, they welcomed the coincidental reference to the snake, since animal imagery was common in CoBrA painting. They were also interested in the art of children. Leading members of CoBrA were Karel Appel, Asger Jorn and Constant Nieuwenhuys (known as Constant). In style their painting was highly expressionist. As a group they had active social and political concerns. CoBrA held a major exhibition in 1949 at the Stedelijk Museum in Amsterdam under the title *International Experimental*

Art, but the group dissolved in the early 1950s.

collage_ Used to describe both the technique and
the resulting work of art in which pieces of paper,
photographs, fabric and other ephemera are arranged
and stuck down to a supporting surface. Collage can
also include other media such as painting and drawing,
and may contain three-dimensional elements. The term
collage derives from the French words *papiers collé*
or *découpage*, used to describe techniques of pasting
paper cut-outs on to various surfaces. It was first used as
an artists' technique in the twentieth century.

Colour Field painting_ Originally used to
describe the work from about 1950 of the Abstract
Expressionist painters Mark Rothko, Barnett Newman
and Clyfford Still, which was characterised by large
areas of a more or less flat single colour. 'The Colour
Field Painters' was the title of the chapter dealing with
these artists in the American scholar Irving Sandler's
groundbreaking history, *Abstract Expressionism*,
published in 1970. Around 1960 a more purely abstract
form of Colour Field painting emerged in the work of
Helen Frankenthaler, Morris Louis, Kenneth Noland
and others. It differed from Abstract Expressionism in
that these artists eliminated the emotional, mythic or
religious content and the highly personal and painterly
or gestural application associated with of the earlier
movement. In 1964 an exhibition of thirty-one artists
associated with this development was organised by the
critic Clement Greenberg at the Los Angeles County
Museum of Art. He titled it *Post-Painterly Abstraction*,
a term often also used to describe the work of the 1960
generation and their successors. In Britain there was
a major development of Colour Field painting in the
1960s in the work of Robyn Denny, John Hoyland,
Richard Smith and others.
(See also Post-Painterly Abstraction)

*comic strip art*_In the 1960s a group of Pop artists began to imitate the commercial printing techniques and subject matter of comic strips. The American painter Roy Lichtenstein became notorious for creating paintings inspired by Marvel comic strips and incorporating and enlarging the Ben Day dots used in newspaper printing – surrounding these with black outlines similar to those used to conceal imperfections in cheap newsprint. At the same time Andy Warhol was also using images from popular culture, including comic strips and advertising, which he repeatedly reproduced, row after row, on a single canvas until the image became blurred and faded. The German painter Sigmar Polke also manipulated the Ben Day dot, although, unlike the slick graphic designs of Lichtenstein, Polke's dots were splodges that looked like rogue accidents in the printing room. In a similar vein, Raymond Pettibon undermined the innocent spirit of the comic strip with his ink-splattered drawings and sardonic commentary.

*complementary colours*_Complementary colours are colours which complete each other – hence the name. The effect of this completing is to enhance the colours – they look stronger when placed together. This is because they contrast with each other more than with any other colours, and we can only see colour by contrast with other colours. The more contrast the more colour. If you stay in a room entirely painted one colour, after about ten minutes it will fade to grey. The complementary colours are the three primary colours, red, blue and yellow, and their secondaries. Secondary colours are the colours obtained by mixing the primaries in all their combinations of pairs. So the three secondary colours are green, orange and violet. The complementary pairs are red-green, blue-orange and yellow-violet. Artists began to become particularly aware of the significance of complementary colours after the development of scientific colour theory in the

nineteenth century. This theory played an important part in the development of <u>Impressionism</u> and <u>Post-Impressionism</u> as well as <u>Fauvism</u> and much modern <u>painting</u> thereafter. The Impressionists were the first to note that shadows are not neutral but are the complementary colour of the light that throws them. So yellow sunlight throws a violet shadow. This can be seen very well in Monet's *Woman Seated on a Bench* in the crease of her arm and the pool of shadow at her feet.

*composition*_In a general sense any piece of music or writing, or any painting or sculpture, can be referred to as a composition. More specifically, the term refers to the way in which an artist has arranged the elements of the work so as to bring them into a relationship satisfactory to the artist and, it is hoped, the viewer. The idea that composition was the adjustment of the relationships of elements within the border of the <u>canvas</u> remained unchallenged through the upheavals of the early modern movements such as <u>Cubism</u> and <u>abstract art</u>. Then in the late 1940s the American <u>Abstract Expressionist</u> painter, Jackson Pollock, introduced what came to be called allover composition, and the traditional concept became known as relational composition. Pollock still generally seems to be composing within the canvas but, at the same time, the Abstract Expressionist Barnett Newman began making paintings in which large blocks of colour ran from top to bottom of the canvas. These were relational to the extent that the proportions of the colours were adjusted against each other, but they were compositionally radical in that the blocks of colour simply ran off the top and bottom edges of the canvas, which Newman deliberately left unframed. It was Frank Stella in the late 1950s who achieved a composition that was allover and at the same time broke out of the confines of the canvas.

*computer animation*_see <u>animation</u>

CERTIFICATE

This is to certify that the Sol LeWitt wall drawing
number_____49_____ evidenced by this certificate is authentic.

A wall divided vertically into fifteen equal
parts, each with a different line direction
and color, and all combinations.

Red, yellow, blue, black pencil
First Drawn by: Chris Hansen, Nina Kayem,
 Al Williams
First Installation: Jewish Museum, New York, NY.
June, 1970

This certification is the signature for the wall drawing and must
accompany the wall drawing if it is sold or otherwise transferred.

Certified by _____
 Sol LeWitt
© Copyright Sol LeWitt_____
 Date

Conceptual art
Sol LeWitt
*A Wall Divided Vertically into
Fifteen Equal Parts, Each with a
Different Line Direction and Colour,
and All Combinations* 1970 (detail)
Graphite on wall surface
Tate. Purchased 1973

*Conceptual art_*This term came into use in the
late 1960s to describe a wide range of types of art that
no longer took the form of a conventional art object.
In 1973 a pioneering record of the early years of the
movement appeared in the form of a book, *Six Years*
by the American critic Lucy Lippard. The 'six years'
were 1966–72. The long subtitle of the book referred
to 'so-called conceptual or information or idea art'.
Conceptual artists do not set out to make a painting or
a sculpture and then fit their ideas to that existing form.
Instead they think beyond the limits of those traditional
media, and then work out their concept or idea in
whatever materials and whatever form is appropriate.
They were thus giving the concept priority over the
traditional media: hence Conceptual art. From this it
follows that Conceptual art can be almost anything, but
from the late 1960s certain prominent trends appeared

such as Performance (or Action) art, Land art, and the
Italian movement Arte Povera (poor art). Poor here
meant using low-value materials such as twigs, cloth,
fat, and all kinds of found objects and scrap. Some
Conceptual art consisted simply of written statements
or instructions. Many artists began to use photography,
film and video. Conceptual art was initially a movement
of the 1960s and 1970s but has been hugely influential
since. Artists include Art & Language, Joseph Beuys,
Marcel Broodthaers, Victor Burgin, Michael Craig-
Martin, Gilbert and George, Yves Klein, Joseph Kosuth,
John Latham, Richard Long, Piero Manzoni and Robert
Smithson.

*Conceptual photography_*The rise of Conceptual
photography in the 1960s coincided with the early
explorations into Video art. Using cameras, artists like
Richard Long and Dennis Oppenheim began recording
their performances and temporary artworks in a manner
that is now often described as deadpan. The aim was to
make simple, realistic images of the artwork that looked
as documentary as possible. It was the pedestrian
nature of photography, its unshakable capacity to
photograph everything the same, that the artists liked,
believing it was the art depicted in the photograph that
was important. Precedents for conceptual photography
can be found as far back as the early twentieth century
when Alfred Stieglitz photographed Marcel Duchamp's
readymade, *Fountain,* for an exhibition in New York.
The original *Fountain* was lost, but the photographs
by Stieglitz remain and have become works of art in
themselves.

*Concrete art_*Term introduced by Theo Van
Doesburg in the 1930 'Manifesto of Concrete Art'
published in the first and only issue of magazine *Art
Concret.* He called for a type of abstract art that would
be entirely free of any basis in observed reality and that

would have no symbolic implications. He stated that there was nothing more concrete or more real than a line, a colour or a plane (a flat area of colour). The Swiss artist Max Bill later became the flag bearer for Concrete art, organising the first international exhibition in Basel in 1944. In practice Concrete art is very close to Constructivism and there is a museum of Constructive and Concrete art in Zurich, Switzerland. (See also Neo-Concrete)

Constructionism_An extension of Constructivism in Britain from about 1950 in the work of Victor Pasmore, Kenneth Martin, Mary Martin and Anthony Hill. Naturally occurring proportional systems and rhythms underpinned their geometrical art. They were inspired by the theories of the American artist Charles Biederman and explored the legacy of the 'Constructive art' made in the 1930s by Ben Nicholson and Barbara Hepworth; also Naum Gabo, whose contribution to Russian Constructivism was exemplary. Hill insisted on using the term Constructionism for the British phenomenon, but Constructivism is more commonly found.

Constructivism_Particularly austere branch of abstract art founded by Vladimir Tatlin and Alexander Rodchenko in Russia around 1915. The Constructivists believed art should directly reflect the modern industrial world. Tatlin was crucially influenced by Pablo Picasso's Cubist constructions, which he saw in Picasso's studio in Paris in 1913. These were three-dimensional still lifes made of scrap materials. Tatlin began to make his own but they were completely abstract and made of industrial materials. By 1921 Russian artists who followed Tatlin's ideas were calling themselves Constructivists and in 1923 a manifesto was published in their magazine *Lef*: 'The material formation of the object is to be substituted for its aesthetic combination. The object is to be treated as a whole and thus will be of no discernible "style" but simply a product of

an industrial order like a car, an aeroplane and such like. Constructivism is a purely technical mastery and organisation of materials.' Constructivism was suppressed in Russia in the 1920s but was brought to the West by Naum Gabo and his brother Antoine Pevsner and has been a major influence on modern sculpture.

*contemporary art_*Term loosely used to denote art of the present day and of the relatively recent past, of an innovatory or avant-garde nature. In relation to contemporary art museums, the date of origin for the term contemporary art varies. The Institute of Contemporary Art in London, founded in 1947, champions art from that year onwards. Whereas The New Museum of Contemporary Art in New York chooses the later date of 1977. In the 1980s, Tate planned a Museum of Contemporary Art in which contemporary art was defined as art of the past ten years on a rolling basis.

*content_*Content generally refers to the subject matter, meaning or significance of a work of art, as opposed to its form. In modern art the dramatic succession of innovations in form from Impressionism onwards have meant that discussion of this has often taken precedence over that of content. In the 1960s and early 1970s the particularly radical flight from traditional forms of art that resulted in what became known as Conceptual art, gave rise to work in which form and content were fused in a new way.

*conversation piece_*Informal group portrait, usually small in scale, showing people – often families, sometimes groups of friends – in domestic interior or garden settings. Sitters are shown interacting with each other or with pets, taking tea, playing games.

*Cubism*_Cubism was a new way of representing reality in art invented by Pablo Picasso and Georges Braque from 1907–8. A third core Cubist was Juan Gris. It is generally agreed the beginning of Cubism was Picasso's celebrated *Demoiselles d'Avignon* of 1907. The name seems to have derived from the comment of the critic Louis Vauxcelles that some of Braque's paintings exhibited in Paris in 1908 showed everything reduced to 'geometric outlines, to cubes'. Cubism was partly influenced by the late work of Paul Cézanne in which he can be seen to be painting things from slightly different points of view. Picasso was also influenced by African tribal masks which are highly stylised, or non-naturalistic, but nevertheless present a vivid human image. In their Cubist paintings Braque and Picasso began to bring different views of single objects together on the picture surface – the object became increasingly fragmented and the paintings became increasingly abstract. They countered this by incorporating words, and then real elements, such as newspapers, to represent themselves (see appropriation). This was Cubist collage, soon extended into three dimensions in Cubist constructions, and it was the start of one of the most important ideas in modern art – that you can use real things directly in art. Cubism was the starting point for much abstract art including Constructivism and Neo-Plasticism. It also, however, opened up almost infinite new possibilities for the treatment of reality in art. (See also Analytical Cubism)

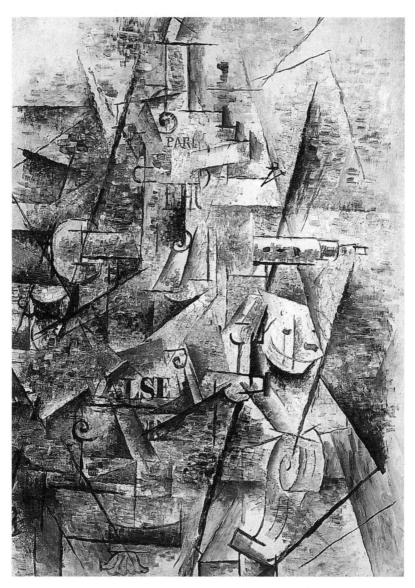

Cubism

Georges Braque
*Clarinet and Bottle of Rum
on a Mantelpiece* 1911
Oil on canvas
81 x 60
Tate. Purchased with assistance
from a special government grant
and with assistance from The Art
Fund 1978

*curator*_Museums and galleries typically employ numbers of curators who are concerned with staging temporary loan exhibitions, arranging displays of the museum's own collection and making acquisitions for that collection. In the past twenty years the role of the curator has evolved: now there are freelance or independent curators who are not attached to an institution and who have their own idiosyncratic ways of making exhibitions. Such curators are invited to curate, or themselves propose, exhibitions in a wide range of spaces, both within and outside the established gallery system, and online. The Swiss curator Harald Szeemann who was the director of the Venice Biennale in 1999 and 2001 is a good example of an independent curator, as is the artist and curator Matthew Higgs who is known for his low-budget, DIY exhibitions that have included the publication *Imprint,* an art exhibition that was posted to people rather than exhibited in a gallery space.

*Dada_*The Dada movement began in Zurich, in neutral Switzerland, during the First World War. It can be seen as a reaction by artists to what they saw as the unprecedented horror and folly of the war. They felt it called into question every aspect of the society capable of starting and then prolonging it, including its art. Their aim was to destroy traditional values in art and to create a new art to replace the old. In 1916 the writer Hugo Ball started a satirical nightclub in Zurich, the Cabaret Voltaire, and a periodical of the same name. In it he wrote of publishing an international review that would bear the name '"DADA" ("Dada") Dada Dada Dada.' This was the first of many Dada publications. Dada became an international movement and eventually formed the basis of Surrealism in Paris after the war. Leading artists associated with it include Hans Arp, Marcel Duchamp, Francis Picabia and Kurt Schwitters. Duchamp's questioning of the fundamentals of Western art had a profound subsequent influence (see readymade).

*data visualisation_*A term used to describe the visual representation of information, often statistical. In the past this was usually in map or graph form, but computers make it possible to represent data in animated and interactive form. Artists use data visualisation as a way of revealing and exploring hidden aspects of society as manifested in new forms of social representation such as web logs. An example of this is *The Dumpster*, an online artwork devised by Golan Levin with Kamal Nigam and Jonathan Feinberg, which uses data from web logs to plot the romantic lives of teenagers.

*Decadence_*Phase or branch of Symbolism in the 1880s and 1890s and many artists and writers are seen

as exponents of both. The term, which came into use in the 1880s (for example the French journal *Le Décadent*, 1886), generally refers to extreme manifestations of Symbolism emphasising the spiritual, the morbid and the erotic. Decadents are inspired partly by disgust at the corruption and rampant materialism of the modern world, partly by the concomitant desire to escape it into realms of the aesthetic, fantastic, erotic or religious. In art key influences were Dante Gabriel Rossetti and then Edward Burne-Jones. Key artists are Fernand Khnopff, Gustave Moreau, Félicien Rops; and from Britain Aubrey Beardsley and Simeon Solomon. Key books associated with Decadence are Joris Karl Huysmans's *A Rebours* (Against Nature) and Oscar Wilde's *Dorian Gray*.

*décollage*_French word meaning literally to unstick. The term is generally associated with the Nouveau Réalisme (new realism) movement, although the first time it appeared in print was in the *Dictionnaire Abrégé du Surréalisme* in 1938. In the context of Nouveau Réalisme it meant making artworks from posters ripped from walls, exhibiting them as aesthetic objects and social documents. The artists involved, such as Raymond Hains, often sought out sites with many layers of posters so that the process of décollage took on an archeological character and was seen as a means of uncovering historical information. From 1949 Hains made work from posters that he tore from the walls of Paris. In 1963 the German artist Wolf Vostell appropriated the term, staging a series of happenings under the title *Nein – 9 Decollagen*. These involved television images that he had *decollé* – unstuck from the screen – and re-presented. In 1962 Vostell had founded *Dé-coll/age: Bulletin Aktueller Ideen*, a magazine devoted to the theoretical writings of artists involved in happenings, Fluxus, Nouveau Réalisme and Pop art.

*deconstruction_*A form of criticism that involves discovering, recognising and understanding the underlying – and unspoken and implicit – assumptions, ideas and frameworks of cultural forms such as works of art. First used by the French philosopher Jacques Derrida in the 1970s, deconstruction asserts that there is not one single intrinsic meaning to be found in a work, but rather many, and often they can be conflicting. In Derrida's 1978 book *La Vérité en peinture* (The truth in painting) he uses the example of Vincent van Gogh's painting *Old Shoes with Laces*, arguing that we can never be sure whose shoes are depicted in the work, making a concrete analysis of the painting difficult. Since Derrida's assertions in the 1970s, the notion of deconstruction has been a dominating influence on many writers and Conceptual artists.

*degenerate art_*The English translation of the German phrase *Entartete Kunst*. In 1933 the National Socialist (Nazi) party, under its leader Adolf Hitler, came to power in Germany and began to bring art under its control. All modern art was labelled degenerate and Expressionism was particularly singled out. In 1937, German museums were purged of modern art by the government, a total of some 15,550 works being removed. A selection of these was then put on show in Munich in an exhibition titled *Entartete Kunst*. This was carefully staged so as to encourage the public to mock the work. At the same time an exhibition was held of traditionally painted and sculpted work which extolled the Nazi party and Hitler's view of the virtues of German life: 'Kinder, Küche, Kirche' – roughly, 'family, home and church'. Ironically, this official Nazi art was a mirror image of the Socialist Realism of the hated Communists. Some of the degenerate art was sold at auction in Switzerland in 1939 and more was disposed of through private dealers. About five thousand items were secretly burned in Berlin later that year.

*digital art*_The first use of the term digital art was in the early 1980s when computer engineers devised a paint program that was used by the pioneering digital artist Harold Cohen. This became known as AARON, a robotic machine designed to make large drawings on sheets of paper placed on the floor. Since this early foray into artificial intelligence, Cohen has continued to fine-tune the AARON program as technology becomes more sophisticated. Digital art can be computer-generated, scanned or drawn using a tablet and a mouse. In the 1990s, thanks to improvements in digital technology, it was possible to download video onto computers, allowing artists to manipulate the images they had filmed with a video camera. This gave artists a creative freedom never experienced before with film, allowing them to cut and paste within moving images to create visual collages. In recent times some digital art has become interactive, allowing the audience a certain amount of control over the final image.

*diptych*_A painting made up by two panels.

*direct carving*_A new approach to making carved sculpture introduced by Constantin Brancusi from about 1906. Before that, carved sculpture had always been based on a carefully worked out preliminary model. Often it was then actually carved by craftsmen employed by the artist: the marble sculptures of Auguste Rodin were made in this way. In direct carving there is no model and the final form evolves through the process of carving. An important aspect of direct carving was the doctrine of truth to materials (see also impasto). This meant that the artist consciously respected the nature of the material, working to bring out its particular properties and the beauty of colour and surface. Direct carvers used a wide variety of types of marble, stone and wood. They kept to simple forms that respected the original block or tree trunk. Surfaces were kept

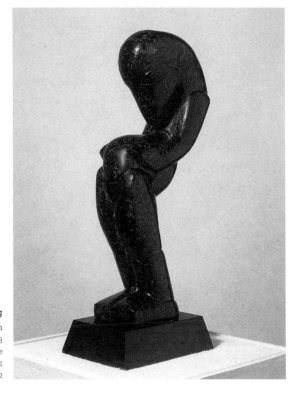

Sir Jacob Epstein
Female Figure in Flenite 1913
Serpentine
45.7 x 9.5 x 12.1
Tate. Purchased 1972

uncluttered by detail in order to expose the material itself and were often carefully polished to enhance the colour and markings. The results were often highly abstract. In introducing this approach Brancusi brought about a revolution in the tradition of carved sculpture. After Brancusi, notable direct carvers were Jacob Epstein, Henri Gaudier-Brzeska, Barbara Hepworth and Henry Moore.

*divisionism*_see Neo-Impressionism

*Documenta*_An exhibition of international contemporary art held in Kassel in Germany, originally every four years, and from 1972 every five years. It is perceived as one of the world's most important art exhibitions. Founded by the artist, teacher and curator

Arnold Bode in 1955, the first Documenta featured, among others, Pablo Picasso, Barbara Hepworth, Ben Nicholson and Max Beckmann. It was created in order to herald a new era after the reactionary aesthetic values of the Nazi period. Sometimes called the Hundred Day Museum, it appoints a new director for every exhibition and the format is often re-invented.

*drawing*_Essentially, drawing is a technique in which images are depicted on a flat surface by making lines, though drawings can also contain tonal areas, washes and other non-linear marks. Ink, pen, pencil (see graphite), crayon, charcoal and chalk are the most commonly used materials, but drawings can be made with or in combination with paint and any other wet or dry media.

*drypoint*_An intaglio process in which incised lines are drawn on a plate with a sharp, pointed needle-like instrument (not the engraving burin). Drypoint is usually done on copper plates as the softer metal lends itself to this technique. The process of incising creates a slightly raised ragged rough edge to the lines, known as the burr. Both the incised line and specifically the burr receive ink when the plate is wiped, giving the printed line a distinctive velvety look. Due to the delicate nature of the burr, drypoint is usually made in small editions, stopping before the burr is crushed by the pressure of the intaglio press. Drypoint is often combined with other etching techniques.

*The Düsseldorf School of Photography*_A group of students at the Kunstakademie Düsseldorf in the mid 1970s who studied under the influential photographers Bernd and Hiller Becher, known for their rigorous devotion to the 1920s German tradition of Neue Sachlichkeit (New Objectivity). The Bechers'

photographs were clear, black and white pictures of industrial archetypes (pitheads, water towers, coal bunkers). Andreas Gursky, Candida Höfer, Axel Hütte, Thomas Ruff and Thomas Struth modified the approach of their teachers by applying new technical possibilities and a personal and contemporary vision, while retaining the documentary method their tutors propounded.

*Earth art*_see Land art

*Ecole des beaux-arts*_French term meaning school of fine arts. The original Ecole des beaux-arts emerged from the teaching function of the French Académie Royale de Peinture et de Sculpture, established in Paris in 1648 (see academy). In 1816 the Académie Royale school moved to a separate building and in 1863 was renamed the Ecole des beaux-arts. The basis of the teaching was the art of ancient Greece and Rome, that is, classical art. Subsequently most major French cities established their own Ecole des beaux-arts. By the end of the nineteenth century the Ecole des beaux-arts had become deeply conservative and independent; rival schools sprang up in Paris, such as the Académie Julian and the Académie Colarossi. The Ecole remained the basic model for an art school until the foundation of the Bauhaus in 1919 (see also Black Mountain College). Most of the illustrious names in French art passed through the Ecole up to and including some of the young Impressionists.

*edition*_A series of identical impressions from the same printing surface. Since the late nineteenth century the number of prints produced has usually been restricted and declared as a 'limited edition'; before this prints were often produced in as many numbers as the process would allow. Modern artists' prints are usually limited to a specified number. Sometimes the quantity is dictated by the process – the plate wears out – but more commonly it is restricted by the artist or publisher, in which case the printing surface is usually destroyed. Editioned prints are usually signed, numbered and often dated by the artist. An edition of twenty-five will be numbered 1/25, 2/25, etc. These are usually accompanied by a number of proof prints, identical to the edition; those produced for the artist are marked 'AP' (artist's proof), those for the printer or publisher are marked 'PP' (printer's proof). A number of working

proofs may also be made. 'Bon à tirer' (good to print)
proofs provide a standard to guide the printer.

*electronic media_*The most common examples of
electronic media are video recordings, audio recordings
(see sound art), slide presentations, CD-ROM and online
content (see browser art; net art; software art). The
term also incorporates the equipment used to create
these recordings or presentations; television, radio,
telephone, computer. Much of the theory surrounding
the use of electronic media by artists is based on Walter
Benjamin's seminal essay of 1936, 'The Work of Art in
the Age of Mechanical Reproduction', which discussed
the democratisation of art, freed from its confines
as a unique entity thanks to the development of
photographic reproduction and forms such as cinema,
where there is no unique original.
(See also digital art)

*embossed_*In printmaking this describes any
process used to create a raised or depressed surface.
It is sometimes used to create false plate-marks in
lithographs or screenprints.

*emulation_*The process of recreating works of
digital art to keep it alive. As technology becomes
more sophisticated, the early video cameras, software
programs and computers of the 1970s and 1980s are
virtually obsolete. Conservators have had to emulate
artworks made on outdated technology – such as
an old Spectrum computer – in existing technology.
This process has caused considerable debate about
the nature of conservation in this context and about
technological nostalgia in contemporary art.

*engraving_*An intaglio technique in which a metal
plate is manually incised with a burin, an engraving tool
like a very fine chisel with a lozenge-shaped tip. The
burin makes incisions into the metal at various angles

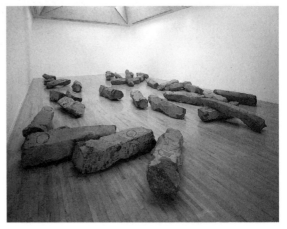

environmental art
Joseph Beuys
The End of the Twentieth Century
1983–5
Basalt, clay and felt
90 x 700 x 1200
Tate. Purchased with assistance
from Edwin C. Cohen
and Echoing Green 1991

and with varying pressure, which dictates the quantity
of ink the line can hold – hence variations in width and
darkness when printed. Photoengraving is a process
using acid to etch a photographically produced image
onto a metal plate that can then be printed from.
(See also wood engraving)

*entropy*_Entropy is the inevitable and steady
deterioration of a system or society. The concept is
articulated by the Second Law of Thermodynamics
(the tendency for all matter and energy in the universe
to evolve towards a state of inert uniformity). In an
art context the term became popular in late 1960s
New York when the artist Robert Smithson used the
term entropy in reference to his contemporaries, the
Minimalist artists Donald Judd, Sol Le Witt, Dan Flavin
and Larry Bell, whose highly simplified and static work
he considered embodied the concept.

*environmental art*_From about the late 1960s the
term environmental art became applied specifically to
art – often, but not necessarily, in the form of installation
– that addressed social and political issues relating to
the natural and urban environment. One of the pioneers

of this was the German artist Joseph Beuys and a notable recent practitioner is Lothar Baumgarten. (See also Land art)

*environments*_see installations

*etching*_An intaglio technique that uses chemical action to produce incised lines in a metal printing plate. The plate, traditionally copper but now usually zinc, is prepared with an acid-resistant ground. Lines are drawn through the ground, exposing the metal. The plate is then immersed in acid and the exposed metal is 'bitten', producing incised lines. Stronger acid and longer exposure produce more deeply bitten lines. The resist is removed and ink applied to the sunken lines, but wiped from the surface. The plate is then placed against paper and passed through an intaglio press with great pressure to transfer the ink from the recessed lines. Sometimes ink may be left on the plate surface to provide a background tone. Etching was used for decorating metal from the fourteenth century, but was probably not used for printmaking much before the early sixteenth century. Since then many etching techniques have been developed, which are often used in conjunction with each other: soft-ground etching uses a non-drying resist or ground, to produce softer lines; spit bite involves painting or splashing acid onto the plate; open bite in which areas of the plate are exposed to acid with no resist; photo-etching (also called photogravure or heliogravure) is produced by coating the printing plate with a light-sensitive acid-resist ground and then exposing this to light to reproduce a photographic image. Foul biting results from accidental or unintentional erosion of the acid-resist.

*Euston Road School*_British Modern Realist group formed in 1938 of artists all of whom either taught or studied at the School of Painting and Drawing at

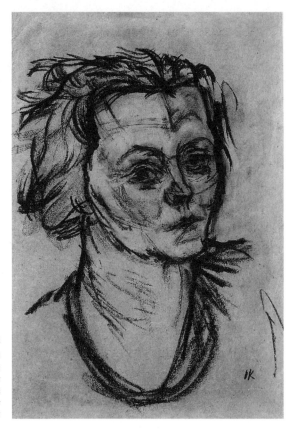

expressionism
Oskar Kokoschka
Dr Fannina W. Halle c.1910-12
Drawing on paper
45.1 x 30.5
Tate. Bequeathed by
Dr Leopold Rubinstein 1977

316 Euston Road in London. They were in conscious reaction against <u>avant-garde</u> styles. Instead they asserted the importance of painting traditional subjects in a realist manner. This attitude was based on a political agenda to create a widely understandable and socially relevant art. Some of them were members of the Communist Party but their work was not propagandist in the manner of <u>Socialist Realism</u>. Artists were Graham Bell, William Coldstream, Lawrence Gowing, Rodrigo Moynihan, Victor Pasmore and Claude Rogers.

*Expressionism*_Specifically, and with a capital letter, the term is associated with modern German art,

particularly the <u>Brücke</u> and <u>Blaue Reiter</u> groups, but this is best referred to as German Expressionism.

*expressionism*_Expressionism as a general term, and with a lower case 'e', refers to art in which the image of reality is distorted in <u>form</u> and colour in order to make it expressive of the artist's inner feelings or ideas about it. In expressionist art colour can be highly intense and non-naturalistic, <u>brushwork</u> is typically free and paint application tends to be generous and highly textured (see <u>impasto</u>). Expressionist art tends to be emotional and sometimes mystical. It can be seen as an extension of Romanticism. In its modern form it may be said to start with Vincent van Gogh and then form a major stream of modern art embracing, among many others, Edvard Munch, <u>Fauvism</u> and Henri Matisse, Georges Rouault, the Brücke and Blaue Reiter groups, Egon Schiele, Oskar Kokoschka, Paul Klee, Max Beckmann, most of Pablo Picasso, Henry Moore, Graham Sutherland, Francis Bacon, Alberto Giacometti, Jean Dubuffet, Georg Baselitz, Anselm Kiefer and the New Expressionism of the 1980s. It went <u>abstract</u> with <u>Abstract Expressionism</u>.

*fairy painting*_A fascination with fairies and the supernatural was a phenomenon of the Victorian age and resulted in a distinctive strand of art depicting fairy subjects drawn from myth and legend and particularly from Shakespeare's play *A Midsummer Night's Dream*. Richard Dadd created keynote paintings, but the most consistent and compelling artist in the genre is John Anster Fitzgerald. Other contributions came from many painters including Edwin Henry Landseer and J.M.W. Turner and illustrators such as Richard Doyle. There was a final flowering in the illustrated books of Arthur Rackham around 1900–14. The influence of fairy painting can be seen to continue in some aspects of Surrealism and Fantastic Realism.

*fake*_A fake or forgery is a copy of a work of art, or a work of art in the style of a particular artist, that has been produced with the intention to deceive. The most infamous forger of the twentieth century was the Dutch painter Han Van Meegren who made a number of paintings purporting to be by Jan Vermeer. (See also replica)

*Fantastic Realism*_Johann Muschik first used the term *Phantastischer realismus* (Fantastic Realism) in the late 1950s to describe a group of painters working in Vienna who had met at the Akademie der Bildenden after the Second World War. The group consisted of Arik Brauer, Ernst Fuchs, Rudolf Hausner, Wolfgang Hutter and Anton Lehmden and was inspired by their teacher Albert Paris Gütersloh, who painted pictures that combined the painterly precision of the old masters with an interest in modern art movements and psychoanalysis. The resulting images were dreamlike visions from the subconscious painted in a realistic manner. Much of the art was rooted in the traumatic experiences of the Second World War, from which the artists attempted to escape in their fantastic paintings.

Fauvism_ Name given to the <u>painting</u> of Henri Matisse, André Derain and their circle from 1905 to about 1910. They were called *les fauves* (the wild beasts) because of their use of strident colour and apparently wild <u>brushwork</u>. Their subjects were highly simplified so their work was also quite <u>abstract</u>. Fauvism can be seen as an extreme extension of the <u>Post-Impressionism</u> of Vincent van Gogh combined with the <u>Neo-Impressionism</u> of Georges Seurat. It can also be seen as a form of <u>Expressionism</u>. The name was coined by the critic Louis Vauxcelles when the work of *les fauves* was shown for the first time at the <u>Salon</u> d'automne in Paris in 1905. Other members of the group included Georges Braque, Raoul Dufy, Georges Rouault and Maurice de Vlaminck.

Federal Art Project_ Short for Works Progress Administration Federal Art Project, an American government programme to give work to unemployed artists during the Great Depression of the 1930s. It was one of a succession of art programmes set up under President Roosevelt's New Deal policy to combat the Depression. In 1933 he set up the Public Works of Art Project, which in five months employed 3,749 artists who produced 15,633 works of art for public institutions. Pictures were expected to be American scenes but otherwise artists were given complete freedom. From 1934 to 1943 the Treasury Section of Painting and Sculpture employed artists to create <u>paintings</u>, <u>murals</u> and <u>sculpture</u> for the embellishment of federal buildings. From 1935 to 1939 the Treasury also ran a parallel scheme, the Treasury Relief Art Fund. The Federal Art Project, administered by the Works Progress Administration, ran from 1935 to 1943 and within a year of the start was employing some 5,500 artists, teachers, designers, craftsmen, photographers and researchers. Some of the most important works that came out of these projects were murals in public buildings, inspired

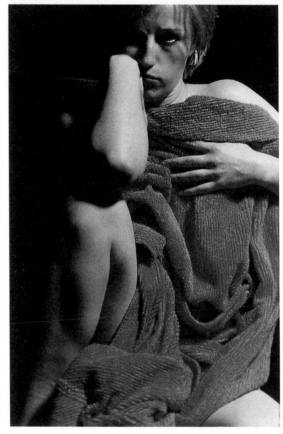

feminist art
Cindy Sherman
Untitled #97 1982
Photograph on paper
115 x 76
Tate. Purchased 1983

by the example of the <u>Mexican Muralists</u>. These programmes gave an enormous boost to art in America – not least by raising the morale of artists – and are now considered to have been a crucial factor in the explosion of creativity in American art following the Second World War (see <u>Abstract Expressionism</u>).
(See also <u>American Social Realist photography</u>)

*feminist art*_May be defined as art by women artists made consciously in the light of developments in feminist art theory since about 1970. In 1971 the art historian Linda Nochlin published a groundbreaking essay 'Why Have There Been No Great Women Artists?'

In it she investigated the social and economic factors that had prevented talented women from achieving the same status as their male counterparts. By the 1980s art historians such as Griselda Pollock and Rozsika Parker were going further, to examine the language of art history with its gender-loaded terms such as 'old master' and 'masterpiece'. They questioned the central place of the female nude in the Western canon, asking why men and women are represented so differently. In his 1972 book *Ways of Seeing* the Marxist critic John Berger concluded 'Men look at women. Women watch themselves being looked at'. In other words Western art replicates the unequal relationships already embedded in society. Feminist art followed a similar trajectory. In what is sometimes known as First Wave Feminist art, women artists revelled in feminine experience, exploring vaginal imagery and menstrual blood, posing naked as goddess figures and defiantly using media such as embroidery that had been considered 'women's work'. One of the great iconic works of this phase of feminist art is Judy Chicago's *The Dinner Party* 1974–9. Later feminist artists rejected this approach and attempted to reveal the origins of our ideas of femininity and womanhood. They pursued the idea of femininity as a masquerade – a set of poses adopted by women to conform to social expectations of womanhood.

*figurative*_Since the arrival of abstract art the term figurative has been used to refer to any form of modern art that retains strong references to the real world and particularly to the human figure. In a general sense figurative also applies retrospectively to all art before abstract art. Modern figurative art can be seen as distinct from modern realism in that figurative art uses modern idioms, while modern realists work in styles predating Post-Impressionism (more or less). In fact, modern figurative art is more or less identical with the general current of expressionism that can be

traced through the twentieth and twenty-first centuries. Pablo Picasso, after about 1920, is the great exemplar of modern figurative painting, and Alberto Giacometti, from about 1940, is the great exemplar of figurative sculpture. After the Second World War figuration can be tracked through the work of Francis Bacon, Lucian Freud and the other artists of the School of London, and through Pop art, Neo-Expressionism and New Spirit painting.

*fin de siècle*_French phrase meaning end of century. As a historical term it applies specifically to the end of the nineteenth century and even more specifically to decade of the 1890s. It is an umbrella term embracing symbolism, Decadence and all related phenomena (for example Art Nouveau) that reached a peak in that decade. Almost synonymous with the terms the Eighteen-Nineties, the Mauve Decade, the Yellow Decade and the Naughty Nineties. Fin de siècle, however, expresses the apocalyptic sense of the end of a phase of civilisation. The spirit was exemplified in France by Henri de Toulouse-Lautrec, and in Britain by Aubrey Beardsley and Charles Conder. The real end came not in 1900 but with the First World War in 1914.

*flâneur*_The nineteenth-century French poet Charles Baudelaire identified the *flâneur* (stroller) in his essay 'The Painter of Modern Life' (1863) as the dilettante observer of modern urban life, a character that features in many Impressionist paintings and was taken up in the twentieth century by the Situationists.

*Fluxus*_An international avant-garde group or collective founded and given its name in 1960 by the Lithuanian-American artist George Maciunas (originally for an eponymous magazine featuring the work of a group of artists and composers centred around John Cage). In Latin the word means flowing;

in English a flux is a flowing out. Maciunas wrote in a Manifesto that the purpose of Fluxus was to 'promote a revolutionary flood and tide in art, promote living art, anti-art'. This has strong echoes of Dada with which Fluxus had much in common. The group coalesced on the continent, first in Germany where Maciunas worked for the US Army. Fluxus subsequently staged a series of festivals in Paris, Copenhagen, Amsterdam, London and New York at which activities included concerts of avant-garde music and performances often spilling out into the street. Almost every avant-garde artist of the time took part in Fluxus, such as Joseph Beuys, Dick Higgins, Alice Hutchins, Yoko Ono, Nam June Paik, Ben Vautier, Robert Watts, Emmett Williams, and the group played an important part in the opening up of definitions of what art can be, leading to the intense and fruitful pluralism seen in art since the 1960s (see Conceptual art, Performance art, Film and Video art, Postmodernism). Its heyday was the 1960s but its influence continues.

*foreshortening_*The treatment of an object or human body in a picture seen in perspective from close to the viewpoint and at right angles to the picture surface. For example a body viewed from either the feet or the top of the head.

*forgery_*see fake

*form_*In relation to art the term form has two meanings. First it refers to the overall form taken by the work – its physical nature. Secondly, within an artwork form refers to the element of shape among the various elements that make up a work. Painting, for example, consists of the elements of line, colour, texture, space, scale and format as well as form. Sculpture consists almost exclusively of form. Until the emergence of modern art, when colour became its rival, form was

the most important element in painting and was based above all on the human body. In treating or creating form in art, the artist aims to modify natural appearances in order to make a new form that is expressive and conveys some sensation or meaning in itself. In modern art the idea grew that form could be expressive even if largely or completely divorced from appearances. In 1914 the critic Clive Bell coined the term 'significant form' to describe this (see formalism). The idea played an important part in abstract art. (See also biomorphic)

*formalism*_In general, the term formalism describes the critical position that the most important aspect of a work of art is its form, that is, the way it is made and its purely visual aspects, rather than its narrative, content or its relationship to the visible world. In painting, therefore, a formalist critic would focus exclusively on the qualities of colour, brushwork, form, line and composition. Formalism as a critical stance came into being in response to Impressionism and Post-Impressionism (especially the painting of Paul Cézanne) in which unprecedented emphasis was placed on the purely visual aspects of the work. In 1890 the Post-Impressionist painter and writer on art, Maurice Denis, published a manifesto titled *Definition of Neo-Traditionism*. The opening sentence of this is one of the most widely quoted texts in the history of modern art: 'Remember, that a picture, before it is a picture of a battle horse, a nude woman, or some story, is essentially a flat surface covered in colours arranged in a certain order.' Denis emphasised that aesthetic pleasure was to be found in the painting itself, not its subject. In Britain formalist art theory was developed by the Bloomsbury painter and critic Roger Fry and the Bloomsbury writer Clive Bell. In his 1914 book *Art*, Bell formulated the notion of 'significant form', that form itself can convey feeling. All this led quickly to abstract art, an art of pure

form. Formalism dominated the development of modern art until the 1960s when it reached its peak in the so-called New Criticism of the American critic Clement Greenberg and others, particularly in their writings on Colour Field painting and Post-Painterly Abstraction. It was precisely at that time that formalism began to be challenged by Postmodernism.

*format*_Format is traditionally used to describe the shape or proportions of the support, for example the canvas, of a painting or other essentially flat work of art such as a relief. The two commonest traditional formats for paintings are the horizontal rectangle often referred to as landscape format and the upright rectangle known as portrait. Another traditional but less common format is the circular one known as the tondo. Square formats have sometimes been used, notably for example by J.M.W. Turner and in the twentieth century Ad Reinhardt. The abstract painter Piet Mondrian occasionally used a square canvas hung by one corner as a diamond. From the 1960s on a much freer approach to format became evident in some of the work of artists such as Frank Stella and Ellsworth Kelly and the shape of the canvas became an important element in the composition of the work.

*found object*_A natural or man-made object (or fragment of an object) found (or sometimes bought) by an artist and kept because of some intrinsic interest the artist sees in it. Found objects may be put on a shelf and treated as works of art in themselves or provide inspiration for the artist. The sculptor Henry Moore collected bones and flints, which he seems to have treated as natural sculptures as well as sources for his own work. Found objects may also be modified by the artist and presented as art, either more or less intact as in the Dada and Surrealist artist Marcel Duchamp's readymades, or as part of an assemblage.

Pablo Picasso was an originator when, from 1912, he began to incorporate newspapers and such things as matchboxes into his Cubist <u>collages</u>, and to make his <u>Cubist</u> constructions from various scavenged materials. Extensive use of found objects was made by Dada, Surrealist and <u>Pop artists</u>, and by later artists such as Carl Andre, Tony Cragg, Bill Woodrow, Damien Hirst, Sarah Lucas and Michael Landy among many others.

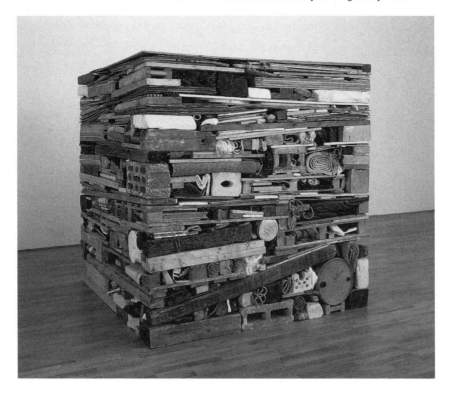

found object
Tony Cragg
Stack 1975
Mixed media
200 x 200 x 200
Tate. Purchased 1997

*frottage*_<u>Surrealist</u> <u>automatist</u> technique developed by Max Ernst in drawings made from 1925. Frottage is the French word for rubbing. Ernst was inspired by an ancient wooden floor where the grain of the planks had been accentuated by many years of scrubbing. The patterns of the graining suggested strange images to him. He captured these by laying sheets of <u>paper</u> on

the floor and then rubbing over them with a soft pencil (see graphite). The results suggest mysterious forests peopled with bird-like creatures and Ernst published a collection of these drawings in 1926 titled *Histoire Naturelle* (Natural History). He went on to use a wide range of textured surfaces and quickly adapted the technique to oil painting, calling it grattage (scraping). In grattage the canvas is prepared with a layer or more of paint then laid over the textured object which is then scraped over. In Ernst's *Forest and Dove* the trees appear to have been created by scraping over the backbone of a fish.

*Futurism_*Art movement launched by the Italian poet Filippo Tommaso Marinetti in 1909. On 20 February he published his *Manifesto of Futurism* on the front page of the Paris newspaper *Le Figaro*. Among modernist movements Futurism was exceptionally vehement in its denunciation of the past. This was because the weight of past culture in Italy was felt as particularly oppressive. In the manifesto, Marinetti asserted that 'we will free Italy from her innumerable museums which cover her like countless cemeteries'. What the Futurists proposed instead was an art that celebrated the modern world of industry and technology: 'We declare ... a new beauty, the beauty of speed. A racing motor car ... is more beautiful than the Victory of Samothrace' (a celebrated ancient Greek sculpture in the Louvre museum in Paris). Futurist painting used elements of Neo-Impressionism and Cubism to create compositions that expressed the idea of the dynamism, the energy and movement of modern life. Chief artists were Giacomo Balla, Umberto Boccioni and Gino Severini. Boccioni was a major sculptor as well as painter.

Futurism

Umberto Boccioni
*Unique Forms of Continuity
in Space* 1913, cast 1972
Bronze
117.5 x 87.6 x 36.8
Tate. Purchased 1972

generative art_Art made by a predetermined system that often included an element of chance. The practice has its roots in <u>Dada</u>, yet it was the pioneering artist Harold Cohen who was considered one of the first practitioners of generative art when he used computer-controlled robots to generate paintings in the late 1960s. More recently the Turner Prize winner Keith Tyson built *Artmachine*, a complex recursive system that generated detailed propositions for artworks for Tyson to make. Generative art is predominantly used in reference to a certain kind of art made on the <u>net</u>, particularly because artists devise programs that can be accessed and controlled by the public. Generative art is also associated with <u>process art</u>.

genres_The genres, or types of <u>painting</u>, were codified in the seventeenth century by the French Royal <u>Academy</u>. In descending order of importance the genres were history, <u>portrait</u>, genre, <u>landscape</u> and <u>still life</u>. This league table, known as the hierarchy of the genres, was based on the notion of man the measure of all things – landscape and still life were the lowest because they did not involve human subject matter. History was highest because it dealt with the noblest events of human history and with religion.

Geometry of Fear_Phrase coined by the British critic and poet Herbert Read in 1952. He used it in a review of the British pavilion at the Venice <u>Biennale</u> of that year. The British contribution was an exhibition of the work of the group of young sculptors that had emerged immediately after the Second World War in the wake of the older Henry Moore. Their work, and that of Moore at that time, was characterised by spiky, alien-like or twisted, tortured, battered or blasted-looking human or animal figures. They were executed in pitted bronze or <u>welded</u> metal and vividly expressed a range of states of mind and emotions related to the anxieties and

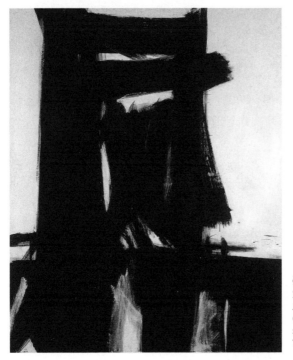

gestural
Franz Kline
Meryon 1960–1
Oil on canvas
235.9 x 195.6
Tate. Purchased 1967

fears of the post-war period. The artists were Robert
Adams, Kenneth Armitage, Reg Butler, Lynn Chadwick,
Geoffrey Clarke, Bernard Meadows, Eduardo Paolozzi
and William Turnbull. A sculpture by Moore was
outside the pavilion. In the Biennale catalogue Read
wrote: 'These new images belong to the iconography of
despair, or of defiance; and the more innocent the artist,
the more effectively he transmits the collective guilt.
Here are images of flight, or ragged claws "scuttling
across the floors of silent seas", of excoriated flesh,
frustrated sex, the geometry of fear.' The quotation
within Read's text is from the poet T.S. Eliot's 'Prufrock'.
The use of the image of 'ragged claws "scuttling"' may
have also referred to Meadows's *Black Crab* 1952.

*gestural_*A term that originally came into use to
describe the painting of the Abstract Expressionist
artists Jackson Pollock, Willem de Kooning, Franz

Kline, Robert Motherwell, Hans Hofmann and others. What they had in common was the application of paint in free sweeping gestures with the brush. In Pollock's case the brush might be a dried one, or a stick, dipped in the paint and trailed over the canvas. He also poured directly from the can. The idea was that the artist would physically act out his inner impulses and that something of his emotion or state of mind would be read by the viewer in the resulting paint marks. De Kooning wrote: 'I paint this way because I can keep putting more and more things into it – drama, anger, pain, love ... through your eyes it again becomes an emotion or an idea.' Such an approach to painting has its origins in Expressionism and Automatism (especially the painting of Joan Miró). In his 1970 history, *Abstract Expressionism*, Irving Sandler distinguished two branches of the movement, the 'Gesture painters' and the 'Colour Field painters'. The term gestural has come to be applied to any painting done in this way.

Glasgow School_ Glasgow School usually refers to the circle of artists and designers in Glasgow from the 1890s to about 1910. Most notable were the sisters, Frances and Margaret Macdonald, Herbert MacNair and Charles Rennie Mackintosh who were known as The Four. They made a distinctive and highly influential contribution to international Art Nouveau and are sometimes referred to as the Spook School. Another group, known as the Glasgow Boys, introduced forms of Impressionism to Scotland in the 1880s and 1890s, developing their own individual interpretations of it, often highly coloured. As well as painting in Glasgow and its environs they sought scenes of rural life and character in other parts of Scotland. Principal members of the group included Joseph Crawhall, Sir James Guthrie, George Henry, E.A. Hornel, Sir John Lavery and E.A. Walton.

*globalisation_*Art has become increasingly internationalised through the Internet and cheap air travel, and through the great international contemporary art exhibitions, such as biennials, and the commercial art fairs, such as Basel and Frieze. Artists are addressing the issues that surround this phenomenon and globalisation refers to both the unifying process that occurs when artists are exposed to the same influences and the art made in response to this. The beginnings of globalisation date back to the early twentieth-century avant-gardist notion of 'the primitive', when artists were influenced by artefacts brought back from Africa and the Far East and incorporated the imagery in their paintings (see Primitivism). The term globalisation was first used in America as a way of defining the growing character of capitalism and in the 1990s an anti-globalisation movement was spawned in response to what people saw as the cultural and economic neo-imperialism of the globalising establishment.

*gouache_*A term first used in France in the eighteenth century to describe a type of paint made from pigments bound in water-soluble gum, similar to watercolour. Larger percentages of binder are used than with watercolour and various amounts of inert pigments such as chalk are added to enhance the opacity. Gouache forms a thicker layer of paint on the paper surface and does not allow the paper to show through. It is often used to create highlights in watercolours. Today the term 'gouache' is often used loosely to describe any drawing made in body colour. Body colour is any type of opaque water-soluble pigment; used by artists from the late fifteenth century. Lead white was used until the introduction of zinc oxide, known as Chinese White, in the nineteenth century.

*graffiti art_*Graffiti has its origins in 1970s New York, when young people began to use spray paint and other materials to create images on the sides of Subway trains. Such graffiti can range from bright graphic images (wildstyle) to the stylised monogram (tag). Graffiti as such is rarely seen in galleries and museums, yet its aesthetic has been incorporated into artists' work. Jean-Michel Basquiat and Keith Haring were both New York graffiti artists who enjoyed considerable commercial success in the 1980s. Their gallery-exhibited work incorporated graffiti styles and they were pioneers of street art. More recently, graffiti and street artists such as Barry McGee and Banksy have been seen exhibited in commercial spaces.

*grattage_*see frottage

*graphite_*A crystalline form of carbon useful as a writing and drawing tool, as only the slightest pressure is needed to leave a mark. However, as graphite is soft and brittle it requires some form of protective casing. The exact date and origin of the first graphite pencil is unknown but it is thought that the first graphite sticks encased in wood appeared around 1565, shortly after the discovery of natural graphite in Cumberland in Britain. Graphite also occurs naturally in Siberia, Bavaria in Germany, and in the United States of America. It can, however, be made artificially by heating cokes at high temperatures, known as the Asheson process. It has a greasy texture and is dull metallic grey in colour. Graphite is a stable and permanent material but can easily be removed using an eraser. Today graphite is referred to as 'pencil' or occasionally 'lead pencil'. This name came about because prior to the discovery of graphite, lead had been used since ancient times as a writing tool. Graphite was thought to be a form of lead until 1779, when K.W. Scheele, a Swedish chemist, discovered that the so-called lead used in pencils, was

in fact a mineral form of carbon. It was named 'graphite'
from the Greek word for writing. The term pencil derives
from the Latin word 'penicillus.'

*Group Zero*_see Zero

*Gruppo Origine*_Italian group (origin group)
founded in Rome in 1951 by Alberto Burri, Ettore Colla,
Giuseppe Capogrossi and Mario Ballocco. Critical of
what they saw as the increasingly decorative quality
of abstract art at the time, they opposed a 'troubled'
consciousness of the world to the progressivist utopia
of the Fronte Nuovo delle Arti neo-cubists and of the
formalist abstraction of the Movimento Arte Concreta
and Forma I groups. In their founding manifesto
they called for a return to fundamentals: 'The Gruppo
Origine intends to become the most morally valid
point of reference of "non-figurative" expressive needs
... By openly renouncing three-dimensional forms, by
reducing colour to its simplest, peremptory and incisive
expressive function, by evoking ... pure and elemental
images, the Group's artists express the necessity of a
rigorous, coherent, energetic vision [which is] primarily
antidecorative.' They held a group exhibition in Rome at
the Galleria Origine in 1951 and disbanded the same year.

*Guerrilla Girls*_A group of anonymous American
female artists who, since their formation in New York in
the mid-1980s, have sought to expose sexual and racial
discrimination in the art world and the wider cultural
arena. The group's members protect their identities
by wearing gorilla masks in public and by assuming
pseudonyms taken from deceased female figures.

*Gutai*_Japanese avant-garde group. Gutai Bijutsu
Kyokai (Gutai Art Association) was formed in 1954 in
Osaka by Yoshihara Jiro, Kanayma Akira, Murakami
Saburo, Shiraga Kazuo and Shimamoto Shozo. The

word has been translated into English as 'embodiment' or 'concrete'. Yoshihara was an older artist around whom the group coalesced and who financed it. In their early public exhibitions in 1955 and 1956 Gutai artists created a series of striking works anticipating later happenings and Performance and Conceptual art. Shiraga's *Challenge to the Mud* 1955, in which the artist rolled half-naked in a pile of mud, remains the most celebrated event associated with the group. Also in 1955 Murakami created his reportedly stunning performance *Laceration of Paper*, in which he ran through a paper screen. At the second Gutai show in 1956, Shiraga used his feet to paint a large canvas sprawled across the floor. From about 1950 Shimamoto had been making paintings from layers of newspaper pasted together, painted and then pierced with holes, anticipating the pierced work of Lucio Fontana. In 1954 Murakami had made a series of paintings by throwing a ball soaked in ink at paper. In 1956 Shimamoto went on to make works called *Throws of Colour* by smashing glass jars filled with pigment onto canvases laid out on the floor. The group dissolved in 1972 following the death of Yoshihara. There was a retrospective exhibition of their work at the Jeu de Paume in Paris in 1999.

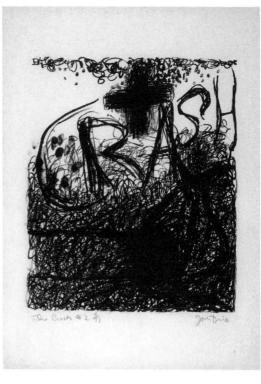

happening
Jim Dine
The Crash #2 1960
Lithograph on paper
53.5 x 44
Tate. Purchased 1990

*happening*_A theatrical event created by artists, initially in America, in the late 1950s and early 1960s. Happenings were the forerunners of <u>Performance art</u> and in turn emerged from the theatrical elements of <u>Dada</u> and <u>Surrealism</u>. The name was first used by the American artist Allan Kaprow in the title of his 1959 work *18 Happenings in 6 Parts* which took place on six days, 4–10 October 1959, at the Reuben Gallery, New York. Happenings typically took place in an environment or <u>installation</u> created within the gallery and involved light, sound, slide projections and an element of spectator participation. Other notable creators of happenings were Claes Oldenburg, Jim Dine, Red Grooms and Robert Whitman. Happenings proliferated through the 1960s but gave way to Performance art in which the focus was increasingly

on the actions of the artist. A detailed account of early happenings can be found in Michael Kirby's 1965 book, *Happenings*. Jim Dine's 1960 suite of prints *The Crash* relates to the drawings that were props for his 1960 happening, *The Car Crash*.

*haptic*_Derived from the Greek word (Haptesthai) meaning 'touch' or 'contact', haptic relates to the way in which humans interact by touch with the world around them. Artists use haptic technology to give the sensation of a physical presence to a virtual object. This can be manifested in several ways: via vibrations in sound installations or using computer software that has input devices that offer touch feedback. An example of this is a computer program that enables the user to paint a picture using virtual 3D brushes.

*Hard Edge painting*_This can be seen as a subdivision of Post-Painterly Abstraction, which in turn emerged from Colour Field painting. The term was coined by the Californian critic Jules Langster in 1959 to describe those abstract painters, particularly on the West Coast, who in their reaction to the more painterly or gestural forms of Abstract Expressionism adopted a particularly impersonal paint application and delineated areas of colour with particular sharpness and clarity. This kind of approach to abstract painting became extremely widespread in the 1960s.

*Harlem Renaissance*_Sometimes known as the New Negro Movement, the Harlem Renaissance was the flowering of black art, literature and music in the United States and in particular Harlem, New York, in the 1920s. Its predominant idea was that through the production of art, literature and music the 'New Negro' could challenge the pervading racism and stereotyping of the white community and therefore promote racial integration. Artists associated with the movement include Aaron Douglas and Lois Mailon Jones.

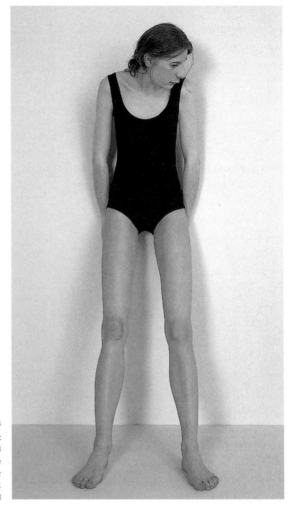

Hyper-Realism
Ron Mueck
Ghost 1998
Fibreglass, silicon, polyurethane
foam, acrylic fibre and fabric
201.9 x 64.8 x 99.1
Tate. Purchased 1998

*Hudson River School_*The collective name given
for a number of North American landscape painters
active between the 1820s and1870s who depicted scenes
of natural beauty in areas that included the Hudson
River Valley and the Catskill Mountains. Prominent
artists associated with the school include Thomas Cole
and Frederic Edwin Church.
(See also Luminism)

*Hyper-Realism*_Term that appeared in the early 1970s to describe a resurgence of particularly high-fidelity realism in sculpture and painting at that time. Also called Super-Realism, and in painting is synonymous with photorealism. In sculpture the outstanding practitioner was Duane Hanson, together with John de Andrea. More recently the work of Ron Mueck and some of that of Robert Gober could be seen as Hyper-Realist. Leading painters were Chuck Close, Robert Bechtle, Richard Estes, Audrey Flack and Ralph Goings.

*iconography*_ The iconography of a <u>painting</u> is the imagery in it. The term comes from the Greek word *ikon*, meaning image. An icon was originally a picture of Christ on a <u>panel,</u> used as an object of devotion in the orthodox Greek Church from at least the seventh century onwards. Hence the term icon has come to be attached to any object or image that is outstanding or has a special meaning attached to it. An iconography is a particular range or system of types of image used by an artist or artists to convey particular meanings. For example, in Christian religious painting there is an iconography of images such as the lamb which represents Christ, or the dove which represents the Holy Spirit. In the iconography of classical myth, however, the presence of a dove would suggest that any woman also present would be the goddess Aphrodite or Venus, so the meanings of particular images can depend on context. In the eighteenth century William Blake invented a complex personal iconography to illustrate his vision of man and God, and much scholarship has been devoted to interpreting it. In the twentieth century the iconography of Pablo Picasso's work is mostly autobiographical, while Joseph Beuys developed an iconography of substances such as felt, fat and honey to express his ideas about life and society. Iconography (or iconology) is also the academic discipline of the study of images in art and their meanings.

*illusionism*_ In Baroque art, illusionism refers particularly to decorative schemes in buildings, especially ceiling <u>paintings</u>, in which the artist uses <u>perspective</u> and <u>foreshortening</u> to create, for example, the illusion that the ceiling is open sky populated by groups of figures such as saints or angels. Such effects are also sometimes referred to as *trompe l'oeil*, a French phrase meaning 'deceives the eye'. More generally illusionism can refer to any painting that strives to achieve a high degree of mimesis, meaning imitation

impasto
Leon Kossoff
*Christ Church, Spitalfields,
Morning* 1990
Oil on board
198.6 x 189.2
Tate. Purchased 1994

of reality. In modern art theory illusionism has been frowned upon on the grounds that it denies the basic truth of the flatness of the canvas. However, <u>Surrealist</u> artists such as Salvador Dalí and René Magritte have used it to great effect to evoke the alternative world of the unconscious mind.

*impasto*_An area of thick paint or texture in a <u>painting</u>. The use of impasto became more or less compulsory in modern art as the view took hold that the

surface of a painting should have its own reality rather than just being a smooth window into an illusionistic world beyond. With this went the idea that the texture of paint and the brushwork could themselves help to convey feeling, that they are a kind of handwriting, that they can directly express the artist's emotions or response to the subject (see also gestural). A painting in which impasto is a prominent feature can also be said to be painterly. This term carries the implication that the artist is revelling in the manipulation of the oil paint itself and making the fullest use of its sensuous properties. The idea that the artist should foreground the innate qualities of the materials of the work as part of its content is a central one in modern art, and is summarised in the phrase 'truth to materials'. (See also direct carving)

*Impressionism*_A new way of painting landscape and scenes of everyday life, developed in France by Claude Monet and others from the early 1860s. Based on the practice of painting finished pictures out of doors, as opposed to simply making sketches (and actually practised in Britain by John Constable around 1813–17), the result was greater awareness of light and colour and the shifting pattern of the natural scene. Brushwork became rapid and broken into separate dabs to render these effects. The first group exhibition in Paris in 1874 was greeted with derision, Monet's *Impression, Sunrise* being particularly singled out and giving its name to the movement. Seven further exhibitions were held at intervals up until 1886. Other core artists were Camille Pissarro, Auguste Renoir, plus Edgar Degas and Edouard Manet in a slightly tangential relationship. A second generation manifested itself in Post-Impressionism.

*Independent Group_*A radical group of young
artists within the Institute of Contemporary Arts
(ICA) in London. The Independent Group, or IG, was
first convened in the winter of 1952–3 and then again
in 1953–4. It was responsible for the formulation,
discussion and dissemination of many of the basic
ideas of British Pop art and of much other new British
art in the late 1950s and early 1960s. Leading artists
involved were Richard Hamilton, Nigel Henderson,
John McHale, Eduardo Paolozzi and William Turnbull.
The IG also included the critics Lawrence Alloway
and Rayner Banham, and the architects Colin St John
Wilson, and Alison and Peter Smithson (see Brutalism).
In 1953 the IG staged the exhibition *Parallel of Art and
Life* and in 1956 the ground-breaking *This is Tomorrow*.
This exhibition at the Whitechapel Gallery in London
was an expression of the IG's pioneering interest in
popular and commercial culture and consisted of
a series of installations, and a jukebox that played
continuously.

*industrial design_*The design of mass-produced,
machine-made goods. The word was first used in
America in the 1920s to describe the work of specialist
designers who worked on product design. Earlier,
Henry Ford's introduction in 1913 of the production
line to the motor car industry, and subsequently to
the production of other merchandise, led to a move
in the art world to attempt to weld art and technology
together. Constructivism in Russia and the Bauhaus
in Germany were inspired by the new machine age;
putting emphasis on form following function they
created design that had an abstract, geometric form.

*ink_*An ancient drawing and writing medium, ink is
still most commonly made of carbon and binders, but
historically was also made from plant or animal sources
such as iron gall and sepia. Inks are traditionally black

or brown in colour, but can also contain coloured dyes or pigments. They are traditionally used with sable brushes or varieties of quill, reed or pen.

*installation_*Also described as environments, the term is used to describe <u>mixed media</u> constructions or <u>assemblages</u> usually designed for a specific place and for a temporary period of time. Works often occupy an entire room or gallery space that the spectator invariably has to walk through in order to engage fully with the work of art. Some installations, however, are designed simply to be walked around and contemplated, or are so fragile that they can only be viewed from a doorway, or one end of a room. One of the originators of environments was the American artist Allan Kaprow in works made from about 1957 onwards. From that time on the creation of installations became a major strand in modern art, increasingly from about 1990, and many artists have made them. In 1961 in New York, Claes Oldenburg created an early environment, *The Store*, from which his *Counter and Plates with Potato and Ham* comes. One of the outstanding creators of installations using light is James Turrell. Miscellaneous materials (mixed media), light and <u>sound</u> have remained fundamental to Installation art.

*institutional critique_*The act of critiquing an institution as artistic practice, the institution usually being a museum or an art gallery. Institutional criticism began in the late 1960s when artists began to create art in response to the institutions that bought and exhibited their work. In the 1960s the art institution was often perceived as a place of 'cultural confinement' and thus something to attack aesthetically, politically and theoretically. Hans Haacke is a leading exponent of institutional critique, particularly targeting funding and donations given to museums and galleries. In 1971, the Wallraf-Richartz Museum, Cologne rejected his

work *Manet-Projekt 74* from one of their shows. The work was related to the museum's recent acquisition of Edouard Manet's *Bunch of Asparagus* and detailed the provenance of the painting and Nazi background of the donor. During the 1990s it became a fashion for critical discussions to be held by curators and directors within art galleries and museums that centred on this very subject, thereby making the institution not only the problem but also the solution. This has changed the nature of institutional critique, something that is reflected in the art of Carey Young, who considers this dilemma.
(See also Guerrilla Girls)

*intaglio_*Any form of printmaking in which the image is produced by incising into the printing plate and where it is the incised line or area that holds the ink. Intaglio methods include etching, drypoint, engraving and wood engraving.

*International Style_*In 1932 the Museum of Modern Art in New York held the first architectural exhibition featuring architects associated with the Modern Movement. International Style was the term coined by historian Henry-Russell Hitchcock and architect Philip Johnson for the catalogue. Most of the architects defined by International Style were European with a considerable German brigade emerging from the Bauhaus, namely Walter Gropius, Marcel Breuer, Ernst May, Erich Mendelsohn, Mies van der Rohe and Hans Scharoun; other Europeans included France's Le Corbusier, Italy's Luigi Figini and Finland's Alvar Aalto. The majority of the buildings defined by International Style were similar in that they were rectilinear, undecorated, asymmetrical and white, although after the Second World War this was modified as a matter of economy in dealing with post-war reconstruction and, later, with the introduction of

industrial steel and glass. International Style is seen as single-handedly transforming the skylines of every major city in the world with its simple cubic forms.

*Internet art*_see <u>net art</u>

*intimism*_Originally a French term (*intimisme*) applied to the quiet domestic scenes of Pierre Bonnard and Edouard Vuillard in the early twentieth century. Since then it has been applied widely to any <u>painting</u> of such subject matter. An outstanding example is Gwen John.

intimism
Pierre Bonnard
Bathing Woman,
Seen from the Back c.1919
Oil on canvas
44.1 x 34.6
Tate. Bequeathed by the Hon. Mrs
A.E. Pleydell-Bouverie through the
Friends of the Tate Gallery 1968

*japonisme_*Said to have been coined by the French critic Philippe Burty in the early 1870s. It described the craze for Japanese art and design that swept France and elsewhere after trade with Japan resumed in the 1850s, the country having been closed to the West since about 1600. The rediscovery of Japanese art and design had an almost incalculable effect on Western art. The development of modern painting from Impressionism onwards was profoundly affected by the flatness, brilliant colour and high degree of stylisation, combined with the realist subject matter, of Japanese woodcut prints. Design was similarly affected in the Aesthetic Movement and Art Nouveau.

*kinaesthetic art_*Kinaesthesia is the sense that detects bodily position, weight or movement of the muscles, tendons and joints of the body. The term has come to be used in relation to art that deals with the body in movement. It was first associated with Futurism, which sought to champion the dynamism of the modern age by depicting people and things in motion. The performances of the American choreographer Merce Cunningham can also be described as kinaesthetic, because his dancers are concerned with the exploration of space through the body's movement. In 1973 Trisha Brown used the Manhattan skyline as a stage for her performance *Roof Piece* in which dancers transmitted movements to other dancers standing on rooftops across New York.

*kinetic art_*The word kinetic means 'relating to motion'. Kinetic art depends on motion for its effects. Since the early twentieth century artists have been incorporating movement into art. This has been partly to explore the possibilities of movement, partly to introduce the element of time, partly to reflect the importance of the machine and technology in the modern world and partly to explore the nature of vision.

kinetic art

Naum Gabo
Kinetic Construction (Standing Wave) 1919–20, replica 1985
Metal, painted wood and electrical mechanism
61.6 x 24.1 x 19
Tate. Presented by the artist through the American Federation of Arts 1966

Movement has either been produced mechanically by motors or by exploiting the natural movement of air in a space. Works of this latter kind are called mobiles. A pioneer of kinetic art was Naum Gabo with his motorised *Standing Wave* of 1919–20. Mobiles were pioneered by Alexander Calder from about 1930. Kinetic art became a major phenomenon of the late 1950s and the 1960s.

*Kitchen Sink painters_*Originally used as the title of an article by the critic David Sylvester in the December 1954 issue of the journal *Encounter*. The article discussed the work of the British realist artists known as the Beaux Arts Quartet, John Bratby, Derrick

kitsch
John Currin
Honeymoon Nude 1998
Oil on canvas
116.8 x 91.4
Tate. Purchased with assistance
from Evelyn, Lady Downshire's
Trust Fund 1999

Greaves, Edward Middleditch and Jack Smith. Sylvester
wrote that their work 'takes us back from the studio
to the kitchen' and described their subjects as 'an
inventory which includes every kind of food and drink,
every utensil and implement, the usual plain furniture
and even the babies' nappies on the line. Everything
but the kitchen sink? The kitchen sink too.' Sylvester
also emphasised that these kitchens were ones 'in
which ordinary people cooked ordinary food and
doubtless lived their ordinary lives'. The Kitchen Sink
painters' celebration of the everyday life of ordinary
people carries implications of a social if not political
comment and Kitchen Sink art can be seen to belong
in the category of <u>Social Realism</u>. Kitchen Sink reached
its apogee in 1956 when the Beaux Arts Quartet was
selected to represent Britain at the Venice <u>Biennale</u>.

*kitsch*_The German word for trash that came into use in English sometime in the 1920s to describe particularly cheap, vulgar and sentimental forms of popular and commercial culture. In 1939 the American art critic Clement Greenberg published a famous essay titled 'Avant-Garde and Kitsch'. In it he defined kitsch and examined its relationship to the high-art tradition as continued in the twentieth century by the avant-garde: 'Where there is an avant-garde, generally we also find a rear-guard. True enough – simultaneously with the entrance of the avant-garde, a second new cultural phenomenon appeared in the industrial West: that thing to which the Germans give the wonderful name of Kitsch: popular, commercial art and literature with their chromeotypes, magazine covers, illustrations, ads, slick and pulp fiction, comics, Tin Pan Alley music, tap dancing, Hollywood movies, etc., etc.' Some more up-to-date examples of kitsch might include plastic or porcelain models of the late Diana, Princess of Wales, Japanese manga comics and the Hello Kitty range of merchandise, many computer games, the whole of Las Vegas and Disneyland, and the high-gloss soft porn of Playboy magazine. Greenberg saw kitsch as the opposite of high art but from about 1950 artists started to take a serious interest in popular culture, resulting in the explosion of Pop art in the 1960s. This engagement with kitsch has continued to surface in movements such as Neo-Geo and in the work of artists such as John Currin or Paul McCarthy.

*kunsthalle*_A German term for a public art space that mounts temporary exhibitions. In Germany they are often supported by the local *kunstverein* (art association). It has come to be used internationally as a term for a publicly funded art space usually devoted to contemporary art.

1

Land art
Richard Long
A Line Made by Walking 1967
Photograph and pencil on board
37.5 x 32.4
Tate. Purchased 1976

*Lacanian*_Referring to the thought of the prominent French psychoanalyst and theorist Jacques Lacan, who postulated a distinction between experience that is 'imaginary' – associated with the 'gaze' of an active spectator, characterised as being motivated by desire – and 'symbolic' – an area of experience that is approached through language. He had a strong influence on Postmodernism.

*Land art*_Also known as Earth art. It can be seen as part of the wider Conceptual art movement in the 1960s and 1970s. Land artists began working directly in the landscape, sculpting into earthworks or making structures with rocks or twigs. Some of them used mechanical earth-moving equipment, but Richard Long simply walked up and down until he had made a mark in the earth. Land art was usually documented in artworks using photographs and maps that the artist could

exhibit in a gallery. Land artists also made artworks in the gallery by bringing in material from the landscape and using it to create installations. Arguably, the most famous Land artwork is Robert Smithson's *Spiral Jetty* of 1970, an earthwork built out into the Great Salt Lake in the USA. Other Land artists include Walter de Maria, Michael Heizer and Dennis Oppenheim.

*landscape*_One of the principal types or genres of Western art. However, the appreciation of nature for its own sake and its choice as a specific subject for art is a relatively recent phenomenon. Until the seventeenth century landscape was confined to the background of paintings dealing principally with religious, mythological or historical subjects. When, also in the seventeenth century, the French Academy classified the genres of art, it placed landscape fourth in order of importance out of five genres. Nevertheless, landscape painting became increasingly popular through the eighteenth century. The nineteenth century saw a remarkable explosion of naturalistic landscape painting, partly driven by the notion that nature is a direct manifestation of God, and partly by the increasing alienation of many people from nature by growing industrialisation and urbanisation. Britain produced two outstanding contributors to this phenomenon in John Constable and J.M.W. Turner. The baton then passed to France where, in the hands of the Impressionists, landscape painting became the vehicle for a revolution in Western painting and the traditional hierarchy of the genres collapsed.

*Lettrisme*_Founded by the Romanian-born artist Isidore Isou in the mid-1940s, this French avant-garde movement was associated with the Situationist branch of the Anarchist family and became the art that dominated posters and barricades in the Parisian student riots of Spring, 1968. Lettrisme is a form of

visual poetry: using calligraphic techniques it began by artists superimposing letters on various objects from furniture to film. This practice foreshadowed layering and other computer techniques, and because of this it is sometimes called hypergraphie. Both mail art and contemporary graffiti art, which share many of Lettrisme's basic characteristics, could be said to have evolved out of Lettrisme.

*lightbox*_A box fitted with an internal light source, commonly a fluorescent tube or small incandescent bulbs, and a translucent white surface. Normally used for examining transparencies and negatives and tracing works made with a variety of techniques and materials. However, since the late twentieth century artists have made works in which large-scale photographic transparencies are presented fitted on a lightbox to create an integral work.

*linocut*_A relief print produced in a manner similar to woodcut. The lino block consists of a thin layer of linoleum (a canvas backing coated with a preparation of solidified linseed oil) usually mounted on wood. The soft linoleum can be cut away more easily than a woodblock and in any direction (no grain) to produce a raised surface that can be inked and printed. Its slightly textured surface accepts ink evenly. Linoleum was invented in the nineteenth century as a floor covering; it became popular with artists and amateurs for printmaking in the twentieth century.

*lithography*_A printing process based on the antipathy of grease and water. The image is applied to a grained surface (traditionally stone but now usually aluminium) using a greasy medium: greasy ink (tusche), crayon, pencils, lacquer or synthetic materials. Photochemical or transfer processes can be used. A solution of gum arabic and nitric acid is then

applied over the surface, producing water-receptive non-printing areas and grease-receptive image areas. The printing surface is kept wet, so that a roller charged with oil-based ink can be rolled over the surface, and ink will only stick to the grease-receptive image area. Paper is then placed against the surface and the plate is run through a press. Lithography was invented in the late eighteenth century, initially using Bavarian limestone as the printing surface. Its invention made it possible to print a much wider range of marks and areas of tone than with earlier printmaking techniques. It also made colour printing easier: areas of different colours can be applied to separate stones and overprinted onto the same sheet. Offset lithography involves printing the image onto an intermediate surface before the final sheet. The image is reversed twice, and appears on the final sheet the same way round as on the stone or plate.

*Live art*_Mainly refers to Performance art and its immediate precursor happenings, together with the developments of Performance since the 1960s. In 1999 the publicly funded Live Art Development Agency was founded in London, UK, to promote and co-ordinate activity in this field. Live art may also refer to art using living animals or plants. A major practitioner of this has been the Arte Povera artist Jannis Kounellis.

*London Group*_In 1913 this group took over from the Camden Town Group the organising of modern art exhibitions in Britain. Its stated aim was 'to advance public awareness of contemporary visual art by holding exhibitions annually'. Its first president was Harold Gilman, one of the leading Camden Town painters. As an exhibiting society the London Group was specifically in opposition to the conservatism of the Royal Academy. It was also in opposition to the New English Art Club that, once avant-garde, had become conservative. Its strength was that it embraced the whole spectrum of

modern art in Britain at the time, spanning Camden Town, Bloomsbury and Vorticism. The first exhibition was held in 1914 at the Goupil Gallery in London. This and the next few exhibitions included some of the icons of modern British art of the time. Among these was David Bomberg's *In the Hold*, Jacob Epstein's *Rock Drill* and Mark Gertler's anti-war painting *Merry-Go-Round*. The London Group flourished in the 1920s, when the Bloomsbury painter and critic Roger Fry played a prominent role, maintaining its support for the principles of modern French art. From about 1930 it gradually lost its pre-eminence as the showcase for modern art in Britain, but the Group still exists and holds exhibitions.

*luminism*_Term meaning, roughly, 'painting of light'. Applied specifically to American landscape painters of the Hudson River School, many of their paintings were dominated by intense and often dramatic light effects. It is sometimes applied to Neo-Impressionist paintings in which the divisionist technique leads to a marked all-over luminosity.

Magic Realism _Term invented in 1925 by German photographer, art historian and art critic Franz Roh in his book *Nach Expressionismus: Magischer Realismus* (After Expressionism: Magic Realism). It describes modern realist paintings with fantasy or dream-like subjects. In Central Europe Magic Realism was part of the reaction against modern or avant-garde art, known as the 'return to order', that took place generally after the First World War. Artists included Giorgio de Chirico, Alberto Savinio and others in Italy, and Alexander Kanoldt and Adolf Ziegler in Germany (see also Neue Sachlichkeit). Magic Realism is closely related to oneiric Surrealism and Neo-Romanticism in France. The term is also used of certain American painters in the 1940s and 1950s including Paul Cadmus, Philip Evergood and Ivan Albright. In 1955 the critic Angel Flores used Magic Realism to describe the writing of Jorge Luis Borges and Gabriel García Márquez, and it has since become a significant, if disputed, literary term.

*mail art*_Considered to be the predecessor of net art, mail art began in the 1960s when artists sent postcards inscribed with poems or drawings through the post rather than exhibiting or selling them through conventional commercial channels. Its origins can be found in Marcel Duchamp and Kurt Schwitters and the Italian Futurists, although it was the New York artist Ray Johnson who, in the mid-1950s, posted small collages, prints of abstract drawings and poems to art world notables, giving rise to what eventually became known as the New York Correspondence School. Mail art can take a variety of forms including postcards, packages, faxes, emails and blogs. In the 1960s the Fluxus artist On Kawara sent telegrams to friends and family that informed them he was alive. In the mid-1990s, the artist and curator Matthew Higgs set up Imprint, which posted art by young British artists, among them Martin Creed, to critics and curators.

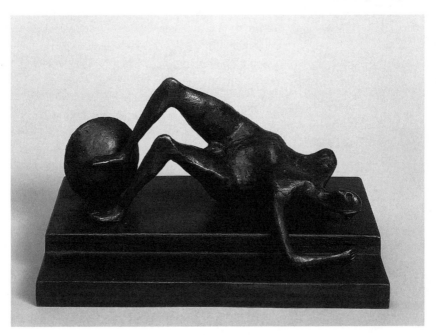

maquette_A model for a larger piece of <u>sculpture</u>. Often fascinating works in their own right, maquettes convey the immediacy of the artist's first realisation of an idea.

matter painting_The term appeared in the 1950s and referred to the use of thick <u>impasto</u> into which other materials were often inserted. These included sand, mud, cement and shells. Matter painting was popularised by a group of Dutch and Belgian painters such as Bram Bogart, Jaap Wagemaker, Bert de Leeuw, René Guiette and Marc Mendelson. Its intention was to highlight the nature of painting and its materials. Other artists whose work is often associated with matter painting are the French painter and sculptor Jean Dubuffet, the Spanish artist Antoni Tàpies and the American painter Julian Schnabel.

maquette
Henry Moore
Maquette for Fallen Warrior 1956
Bronze
14 x 15.5 x 26.5
Tate. Presented by Gustav and
Elly Kahnweiler 1974 and
accessioned 1994

*medium*_In relation to art this term has two principal overlapping, even slightly confusing meanings. Painting, sculpture, drawing and printmaking are all media of art in the sense of a type of art. However, the term can also refer to the materials of the work. For example, a sculpture in the medium of bronze or marble; a painting in the medium of oil paint on canvas, tempera on panel or watercolour on paper; a drawing in the medium of graphite or crayon; a print in the medium of etching or lithography. In modern art new media in both senses have appeared. First of all, modern artists, from Pablo Picasso and Marcel Duchamp onwards, have established that art can be made of absolutely any material, so the media of modern art, in that sense, have ranged from appropriated or found objects and materials of all kinds, to the artist's own bodily excretions and the body itself. Many modern works are made from a variety of such things and the term mixed media has had to be coined to take account of this. This expansion of media, in the sense of materials, has given rise to new media in the overarching sense of a type of art. For example, assemblage, installation and performance are all three-dimensional art forms sufficiently distinct from traditional sculpture to become considered new media in themselves. In the case of the first two, the medium from which they are usually made is a variety of materials, that is, mixed media. Performance art uses the artist's own body as the material or medium. Finally, in a third meaning, the term medium also refers to the liquid in which the pigment is suspended to make paint. So the medium of the medium of oil paint is linseed oil.
(See also electronic media; multi-media; new media; time-based media)

*memento mori*_Latin phrase meaning 'remember you must die'. A memento mori painting or sculpture is one designed to remind the viewer of their mortality and of

the brevity and fragility of human life in the face of God
and nature. A basic memento mori painting would
be a portrait with a skull, but other symbols commonly
found are hourglasses or clocks, extinguished or guttering
candles, fruit and flowers. Closely related to the memento
mori picture is the vanitas still life. In addition to the
symbols of mortality these may include other symbols
such as musical instruments, wine and books to remind us
explicitly of the vanity (in the sense of worthlessness) of
worldly pleasures and goods. The term originally comes
from the opening lines of the Book of Ecclesiastes in the
Bible: 'Vanity of vanities, saith the Preacher, vanity of
vanities, all is vanity.' Vanitas and memento mori pictures
became popular in the seventeenth century, in a religious
age when almost everyone believed that life on earth was
merely a preparation for an afterlife. However, modern
artists have continued to explore this genre.

memento mori
Pablo Picasso
Goat's Skull, Bottle and Candle 1952
Oil on canvas
89.2 x 116.2
Tate. Purchased 1957

*Merz*_Nonsense word invented by the German Dada artist Kurt Schwitters to describe his collage and assemblage works based on scavenged scrap materials. He made large numbers of small collages, and more substantial assemblages, in this medium. He is said to have extracted the word Merz from the name Commerz Bank, which appeared on a piece of paper in one of his collages. Schwitters founded a Dada group in Hanover where he was based from 1919. There he created his first Merzbau (Merz building). This was his own house, which he filled with about forty 'grottoes' – constructions actually attached to the interior fabric of the building and even extending through windows. In 1937 after his work had been included in the degenerate art exhibition he fled Germany for Norway. There he created a second Merzbau. In 1940 he found refuge in England where he started a third Merzbau at Ambleside in the Lake District. The first Merzbau was destroyed in the Second World War, the second by fire in 1951 and the third was left unfinished at his death in 1947. It is now preserved in the Hatton Gallery at Newcastle University.

*metal*_There are two families of metals: Ferrous and non-ferrous. All ferrous metals contain iron. Non-ferrous metals include aluminium, zinc and copper and its alloys, for example bronze. The use of bronze for making cast sculpture is very ancient. From the early twentieth century artists such as Pablo Picasso and the Russian Constructivists began to explore the use of other metals, and Julio González introduced welded metal sculpture. The use of a range of metals and of industrial techniques became widespread in Minimal art and New Generation sculpture, for example.

*Mexican Muralism*_Term describing the revival of large-scale mural painting in Mexico in the 1920s and 1930s. The three principal artists were José Clemente

Orozco, Diego Rivera and David Alfaro Siqueiros. Rivera is usually considered the chief figure. All three were committed to left-wing ideas in the politically turbulent Mexico of the period and their painting reflects this. Siqueiros in particular pursued an active career in politics, suffering several periods of imprisonment for his activities. Their use of large-scale mural painting in or on public buildings was intended to convey social and political messages to the public. In order to make their work as accessible as possible they all basically worked in realist styles but with distinctively personal differences – Orozco has elements of Surrealism while Siqueiros is vehemently expressionist, for example. The movement can be said to begin with the murals by Rivera for the Mexican National Preparatory School and the Ministry of Education, executed between1923 and 1928. Orozco and Siqueiros worked with him on the first of these. The Mexican Muralists carried out a number of major works in the USA that helped bring them to wide attention and had some influence on the Abstract Expressionists. Notable among these are Rivera's 1932–3 murals in the Detroit Institute of Arts depicting the Ford automobile plant (extant), and at the Rockefeller Center, New York (destroyed on Rockefeller's orders after a press scandal when a portrait of Lenin was noticed in the mural); Orozco's *The Epic of American Civilisation* at Dartmouth College, New Hampshire and his *Prometheus* at Pomona College. California (both extant); and Siqueiros's 1932 *Tropical America* in Los Angeles. This attack on American imperialism in Mexico was painted over some time after it was made, but is now undergoing restoration.

*mezzotint_*A form of engraving where the metal printing plate is indented by rocking a toothed metal tool across the surface. Each pit holds ink, and if printed at this stage the image would be solid black. The printmaker works from dark to light by gradually

Minimal art
Carl Andre
Equivalent VIII 1966
Firebricks
12.7 x 68.6 x 229.2
Tate. Purchased 1972

rubbing down or burnishing the rough surface to various degrees of smoothness to reduce the ink-holding capacity of areas of the plate. The technique was developed in the seventeenth century, and became particularly popular in eighteenth-century England for reproducing portrait paintings. It is renowned for the soft gradations of tone and richness and velvet quality of its blacks.

*Minimal art*_Minimal art or Minimalism is an extreme form of abstract art that developed in the USA in the second half of the 1960s. It can be seen as extending the abstract idea that art should have its own reality and not be an imitation of some other thing. It picked up too on the Constructivist idea that art should be made of modern, industrial materials. Minimal artists typically made works in very simple geometric shapes based on the square and the rectangle. Many Minimal

works explore the properties of their materials. Minimal art was mostly three-dimensional but the painter Frank Stella was an important Minimalist. The other principal artists were Carl Andre, Dan Flavin, Donald Judd, Sol LeWitt, Robert Morris, and Richard Serra. There are strong links between Minimal and Conceptual art. Aesthetically, Minimal art offers a highly purified form of beauty. It can also be seen as representing such qualities as truth (because it does not pretend to be anything other than what it is), order, simplicity and harmony.

*Mir Iskutsstva*_see World of Art (*Mir Iskustsstva*)

mixed media _Works composed of different media. The use of mixed media began around 1912 with the Cubist constructions and collages of Pablo Picasso and Georges Braque and has become widespread as artists developed increasingly open attitudes to the media of art. Essentially art can be made of anything or any combination of things.
(See also assemblage; installation; YBAs)

*mobile*_see kinetic art

*modern realism*_In the nineteenth century Realism had a special meaning as an art term. Since the rise of modern art, realism, realist or realistic has come to be primarily a stylistic description, referring to painting or sculpture that continues to represent things in a way that more or less pre-dates Post-Impressionism and the succession of modern styles that followed. It is also true, however, that much of the best modern realist art has the edginess of subject matter that was the essential characteristic of nineteenth-century realism. In the twentieth century, realism saw an upsurge in the 1920s when the shock of the First World War brought a reaction, known as the 'return to order',

modern realism

Stanley Spencer
Self-Portrait 1959
Oil on canvas
50.8 x 40.6
Tate. Presented by the Friends
of the Tate Gallery 1982

to the <u>avant-garde</u> experimentation of the pre-war
period. In Germany this led to the <u>Neue Sachlichkeit</u>
movement (Otto Dix, Christian Schad) and <u>Magic
Realism</u>. In France, André Derain, previously a <u>Fauve</u>
painter, became a central figure in what was called
traditionisme. In the USA there was the phenomenon
of Regionalism, and the great realist Edward Hopper.
In Britain there was the <u>Euston Road School</u> and the
painter Meredith Frampton. Among other major modern
realist painters are Balthus, Lucian Freud, David Hockney
(in his portraits), Gwen John, Giorgio Morandi and
Stanley Spencer.

*modernism*_In the field of art the broad movement
in Western art, architecture and design which self-
consciously rejected the past as a model for the art of
the present. Hence the term modernist or modern art.

Modernism gathered pace from about 1850 and proposed
new forms of art on the grounds that they were more
appropriate to the present time. It is thus characterised
by constant innovation. But modern art has also been
driven by various social and political agendas. These were
often utopian, and modernism was in general associated
with ideal visions of human life and society and a
belief in progress. The terms modernism and modern
art are generally used to describe the succession of art
movements that critics and historians have identified
since the realism of Gustave Courbet, culminating in
abstract art and its developments up to the 1960s. By that
time modernism had become a dominant idea of art, and
a particularly narrow theory of modernist painting had
been formulated by the highly influential American critic
Clement Greenberg. A reaction then took place that was
quickly identified as Postmodernism.

*monochrome*_Monochrome means one colour.
For centuries artists used different shades (tones) of
brown or black ink to create monochrome pictures on
paper. The ink would simply be more or less diluted to
achieve the required shades. Shades of grey oil paint
were used to create monochrome paintings, a technique
known as grisaille, from the French word *gris* (grey).
In such work the play of light and dark (chiaroscuro)
enabled the artist to define form and create a picture.
In the twentieth century, with the rise of abstract art,
many artists experimented with making monochrome
painting. Among the first was Kasimir Malevich
who about 1917–18 created a series of white on white
paintings (see Suprematism). In Britain, Ben Nicholson
created a notable series of white reliefs in the mid-1930s.
Monochrome painting became particularly widespread
in the second half of the century with the appearance of
Colour Field painting and Minimal art. The French artist
Yves Klein became so famous for his all-blue paintings
that he became known as Yves the monochrome.

monoprint_Essentially a unique variant of a conventional print. An impression is printed from a re-printable block, such as an etched plate or woodblock, but in such a way that only one of its kind exists, for example by incorporating unique hand-colouring or collage. The term can also refer to etchings which are inked and wiped in an expressive, not precisely repeatable manner; to prints made from a variety of printing elements that change from one impression to the next; or to prints that are painted or otherwise reworked by hand either before or after printing.

monotype_A unique image printed from a polished plate, such as glass or metal, painted with ink but not a permanent printing matrix. A monotype impression is generally unique, though a second, lighter impression from the painted printing element can sometimes be made.

montage_An assembly of images that relate to each other in some way to create a single work or part of a work of art. A montage is more formal than a collage and is usually based on a theme. It is also used to describe experimentation in photography and film, in particular the works of Man Ray and Laszlo Moholy-Nagy who made a series of short movies and photographic montages in the 1930s.
(See also photomontage)

mosaic_A picture made up of small parts. Traditionally these parts were made out of terracotta, pieces of glass, ceramics or marble, inlayed into floors and walls. Mosaic has been used as a decorative medium for over five thousand years. It was the Islamic mosaics introduced to Spain by the Moors in the eighth century that inspired the twentieth-century Catalan architect Antoni Gaudí, who arranged pieces of broken glazed tiles with fragments of glass bottles and china

plates over walls in the Park Güell and in parts of the
cathedral of the Sagrada Familia, in Barcelona. Mosaics
also became popular in Mexico, particularly in the art
of Diego Rivera and Juan O'Gorman, who used stone
mosaics in their murals that were based on socialist
ideas and exalted the indigenous and popular heritage
in Mexican culture (see Mexican Muralism). This
workaday ethic became popular again in the 1970s when
artists began rediscovering craft-based techniques. The
British artist Matt Collishaw made a ceramic tile mosaic
of a woman's face taken from a grainy photograph of a
woman found on the Internet.

*motif*_A recurring fragment, theme or pattern that
appears in a work of art. In the past this was commonly
associated with Islamic designs, but it also alludes to a
theme or symbol that returns time and again, like the
noose and the cigarette in the paintings of American
figurative painter Philip Guston, or a pattern, like the
abstract drawings of the mid-twentieth-century abstract
painter Victor Pasmore. The video artist Bill Viola often
uses the motif of water to represent birth and death, as
exemplified in his multi-video installation *Five Angels
for the Millennium*. Motif can also refer to the subject of
the artwork. The phrase 'to paint from the motif' arose
in the context of Impressionism, meaning to paint on
the spot.

*multi-media*_First used in the 1960s in relation to
mixed media works that had an electronic element.
Andy Warhol's events staged with the rock group the
Velvet Underground, under the title of the *Exploding
Plastic Inevitable*, which combined music, performance,
film and lighting, were described as multi-media.
Since the late 1970s multi-media has come to define an
artwork that uses a combination of electronic media,
which could include video, film, audio and computers.

multiple

Roy Lichtenstein
Untitled (Paper Plate) 1969
Screenprint on paper
26.4 x 26.4
Tate. Presented by Simon Wilson
and the Lisson Gallery 1978

*multiple*_ Casting sculpture in bronze, and the various techniques of printmaking, have for many centuries made it possible to make multiple examples of a work of art. Each example of an edition of a print or a bronze is an authentic work of the artist, although there may be technical variations that might affect the value. The number produced is usually strictly limited, mainly for commercial reasons but, in the case of etchings in particular, also for technical reasons – etching plates wear very rapidly, so later impressions are inferior. About 1955, the artists Jean Tinguely and Agam, wanting to make their work more widely available, put forward the idea of very large, effectively unlimited, editions of works that could be sold very cheaply. It is they who seem to have invented the term multiple for such works, which would be made by industrial processes. The first multiples were eventually produced by the Denise René Gallery in

Paris in 1962, and since then large numbers of artists have created multiples.

*mural*_A painting applied directly to a wall in a public space is described as a mural. The popularity of the mural in the Western world began in the nineteenth century, with a new, community-orientated sense of national identity. The advantage of a mural is its accessibility to a large audience, which has endeared it to many political ideologies. In the 1930s there was a worldwide trend towards making art more public in reaction to the introspective development of modern art. In Latin America, the USA and Britain, mural painting became popular thanks to governmental sponsorship in the form of organisations like the Artists International Association. In 1933 Mario Sironi published his *Manifesto of Mural Painting* and commissioned murals by Giorgio de Chirico and Carlo Carrà. In Germany, Italy and the USSR murals reflected the totalitarian propaganda of the State. By the 1970s murals in the Western world were engineered to local politics, often revealing a sense of national, racial or civic pride in the area.
(See also Mexican Muralism)

*Nabis*_Les Nabis (from the Hebrew word for prophet) was a group of <u>Post-Impressionist</u> French painters active from 1888 to 1900. Some of its key members met at the <u>Académie Julian</u> in Paris, which offered a liberal alternative to the official <u>Ecole des beaux-arts</u>. Founded in secret by Paul Sérusier, the group included Pierre Bonnard, Edouard Vuillard and Maurice Denis. Inspired by Paul Gauguin's <u>synthetism</u>, these artists adopted a style characterised by flat patches of colour, bold contours and simplified drawing. Their unconventional outlook led them to experiment with painting on different supports including cardboard and velvet, and to create set designs for symbolist theatre (see <u>symbolism</u>).

*naïve*_The word naïve means simple, unaffected, unsophisticated. As an art term it specifically refers to artists who also have had no formal training in an art school or <u>academy</u>. Naïve art is characterised by childlike simplicity of execution and vision. As such it has been valued by <u>modernists</u> seeking to get away from what they see as the insincere sophistication of art created within the traditional system. The most famous naïve artist of modern times is Henri Rousseau, known as Le Douanier (customs man) from the full-time job he held. Others are André Bauchant and, in Britain, the St Ives seaman Alfred Wallis, whose work famously influenced Ben Nicholson. Naïve artists are sometimes referred to as modern primitives (see <u>primitivism</u>). The category also overlaps with what is called <u>outsider art</u>, or in France, <u>Art Brut</u>. This includes artists who are on the margins of society, such as criminals and mentally ill people.

*narrative*_A narrative is simply a story. Narrative art is art that tells a story. Much of Western art has been narrative, depicting stories from religion, myth and legend, history and literature. Audiences were assumed

to be familiar with the stories in question. From about the seventeenth century genre painting showed scenes and narratives of everyday life. In the Victorian age, narrative painting of everyday life subjects became hugely popular and is often considered as a category in itself (i.e. Victorian Narrative painting). In modern art, formalist ideas have resulted in narrative being frowned upon. However, coded references to political or social issues, or to events in the artist's life, are commonplace. Such works are effectively modern allegories, and generally require information from the artist to be fully understood. The most famous example of this is Pablo Picasso's *Guernica*.

*naturalism_*Until the early nineteenth century both landscape and the human figure in art tended to be idealised or stylised according to conventions derived from the classical tradition. Naturalism was the broad movement to represent things closer to the way we see them. In Britain it was pioneered by John Constable who famously said 'there is room enough for a natural painture' (type of painting). Naturalism became one of the major trends of the century and combined with realism of subject led to Impressionism and modern art. Naturalism was often associated with plein air practice.

*Neo-Concrete_*The Neo-Concrete movement was a splinter group of the Concrete art movement, formed in Brazil in the 1950s. With the construction of the country's new utopian capital, Brasilia, and the formation of the São Paulo Biennial, young Brazilian artists were inspired to create art that drew on contemporary theories of cybernetics, gestalt psychology and the optical experiments of international artists like Bridget Riley and Victor Vasarely (see Op art). Lygia Clark, Lygia Pape, Am'lcar de Castro, Franz Weissmann, Reynaldo Jardim, Sergio Camargo, Theon Spanudis and Ferreira Gullar were

unhappy with the dogmatic approach of the Concrete group, so published the Neo-Concrete manifesto in 1959, which called for a greater sensuality, colour and poetic feeling in Concrete art. In 1960 Hélio Oiticica joined the group and his groundbreaking series of red and yellow painted hanging wood constructions effectively liberated colour into three-dimensional space.

*Neo-Dada*_This term is sometimes applied to the work of Robert Rauschenberg and Jasper Johns in New York in the late 1950s because of their use of collage, assemblage and found objects, and their apparently anti-aesthetic agenda (see Dada). At the time there were also strong echoes of Dada in Installation art and happenings. The term has some justification due to the presence in New York of the great French Dada artist Marcel Duchamp whose ideas were becoming increasingly influential.

*Neo-Expressionism*_This term came into use about 1980 to describe the international phenomenon of a major revival of painting in an expressionist manner. It was seen as a reaction to the Minimalism and Conceptual art that had dominated the 1970s. In the USA leading figures were Philip Guston and Julian Schnabel, and in Britain Christopher Le Brun and Paula Rego. There was a major development of Neo-Expressionism in Germany, as might be expected with its Expressionist heritage, but also in Italy. In Germany the Neo-Expressionists became known as Neue Wilden (new Fauves). In Italy, Neo-Expressionist painting appeared under the banner of Transavanguardia (beyond the avant-garde). In France a group called Figuration Libre was formed in 1981 by Robert Combas, Remi Blanchard, François Boisrond and Hervé de Rosa.

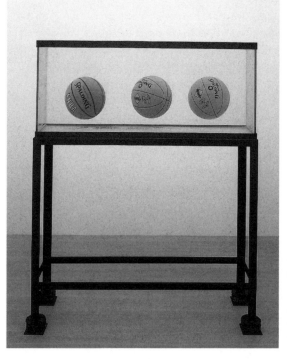

Neo-Geo
Jeff Koons
*Three Ball Total Equilibrium Tank
(Two Dr J Silver Series, Spalding
NBA Tip-Off)* 1985
Mixed media
153.6 x 123.8 x 33.6
Tate. Purchased 1995

*Neo-Geo_*Short for Neo-Geometric Conceptualism.
This term came into use in the early 1980s in America
to describe the work of Peter Halley, Ashley Bickerton,
Jeff Koons and others. Halley in particular was
strongly influenced by the French thinker Jean
Baudrillard. Their work aimed at being a critique of the
mechanisation and commercialisation of the modern
world. Seeing geometry as a metaphor for society,
Halley made brilliantly coloured geometrically <u>abstract
paintings</u>, which, however, have a <u>figurative</u> basis. They
are derived from things such as circuit boards, which
Halley uses to represent the individual organisms
and networks of contemporary urban existence. The
paintings are depictions of the social landscape, of
isolation and connectivity. The work of Bickerton and

Koons was mainly three-dimensional. Koons parodied consumer culture by presenting real consumer goods as works of timeless beauty. Bickerton, in works such as his *Biofragment* series, created a vision of apocalypse.

*Neo-Impressionism*_The name given specifically to the Post-Impressionist work of Georges Seurat and Paul Signac and their followers. Both Camille Pissarro and Lucien Pissarro had a Neo-Impressionist phase and their work continued to bear strong traces of the style. Neo-Impressionism is characterised by the use of the divisionist technique (often popularly but incorrectly called pointillism, a term Signac repudiated). Divisionism attempted to put Impressionist painting of light and colour on a scientific basis by using optical mixture of colours. Instead of mixing colours on the palette, which reduces intensity, the primary-colour components of each colour were placed separately on the canvas in tiny dabs so they would mix in the spectator's eye. Optically mixed colours move towards white so this method gave greater luminosity. This technique was based on the colour theories of M-E. Chevreul, whose *De la loi du contraste simultanée des couleurs* (On the law of the simultaneous contrast of colours) was published in Paris in 1839 and had an increasing impact on French painters from then on, particularly the Impressionists and Post-Impressionists, as well as the Neo-Impressionists.

*Neo-Plasticism*_Term adopted by the Dutch pioneer of abstract art, Piet Mondrian, for his own type of abstract painting. From the Dutch *de nieuwe beelding*, it basically means new art (painting and sculpture are plastic arts). Also applied to the work of the De Stijl circle of artists, at least up to Mondrian's secession from the group in 1923. In the first eleven issues of the journal *De Stijl* Mondrian published his long essay 'Neo-Plasticism in Pictorial Art' in which, among much

else, he wrote: 'As a pure representation of the human mind, art will express itself in an aesthetically purified, that is to say, abstract form … The new plastic idea cannot, therefore, take the form of a natural or concrete representation … this new plastic idea will ignore the particulars of appearance, that is to say, natural form and colour. On the contrary it should find its expression in the abstraction of form and colour, that is to say, in the straight line and the clearly defined primary colour.' Neo-Plasticism was in fact an ideal art in which the basic elements of painting – colour, line, form – were used only in their purest, most fundamental state: only primary colours and non-colours, only squares and rectangles, only straight, horizontal or vertical lines. Mondrian had a profound influence on subsequent art.

*Neo-Romanticism*_Term applied to the imaginative and often quite abstract landscape-based painting of Paul Nash, Graham Sutherland and others in the late 1930s and 1940s. Their work often included figures, was generally sombre, reflecting the Second World War and its approach and aftermath, but rich, poetic and capable of a visionary intensity. It was partly inspired by the landscapes of Samuel Palmer and the Ancients and partly by a more general emotional response to the British landscape and its history. Other major Neo-Romantics were Michael Ayrton, John Craxton, Ivon Hitchens, John Minton, John Piper and Keith Vaughan. The term sometimes embraces Robert Colquhoun and Robert MacBryde, and the early work of Lucian Freud; also the graphic work of Henry Moore of the period, especially his drawings of wartime air raid shelters. In the early 1920s in Paris a group of figurative painters emerged whose brooding, often nostalgic work quickly became labelled Neo-Romantic. Chief among them were the Russian-born trio of Eugène Berman and his brother Leonid, and Pavel Tchelitchew.

*net art_*Art made on and for the Internet is called
net art. This is a term used to describe a process of
making art using a computer in some form or other,
whether to download imagery that is then exhibited
online or build programs that create the artwork.
Net art emerged in the 1990s when artists found that
the Internet was a useful tool to promote their art
uninhibited by political, social or cultural constraints.
For this reason it has been heralded as subversive, deftly
transcending geographical and cultural boundaries
and defiantly targeting nepotism, materialism and
aesthetic conformity. Sites like MySpace and YouTube
have become forums for art, enabling artists to exhibit
their work without the endorsement of an institution.
Pioneers of net art include Tilman Baumgarten, Jodi
and Vuc Cosik.
(See also browser art; software art)

Neue Künstlervereinigung München (NKV)_
The 'New Artists' Association of Munich' was founded
as an avant-garde exhibiting society in Munich in 1909.
With Wassily Kandinsky as president and members
including Alexei Jawlensky and Gabriele Münter,
the association mounted controversial exhibitions
of Fauvist-influenced work in 1909, 1910 and 1911.
Kandinsky resigned in 1911 and with Franz Marc, who
had defended the NKV against widespread criticism the
previous year, founded the Blaue Reiter.

*Neue Sachlichkeit_*Usually translated as New
Objectivity this was a German modern realist movement
of the 1920s, taking its name from the exhibition *Neue
Sachlichkeit* held in Mannheim in 1923. It was part of
the phenomenon of the 'return to order' following the
First World War. The two key artists associated with
Neue Sachlichkeit are Otto Dix and George Grosz, two
of the greatest realist painters of the twentieth century.
In their paintings and drawings they vividly depicted

and excoriated the corruption, frantic pleasure-seeking
and general demoralisation of Germany following its
defeat in the war and the ineffectual Weimar Republic
which governed until the arrival in power of the Nazi
Party in 1933. But their work also constitutes a more
universal, savage satire on the human condition. Other
artists include Christian Schad and Georg Schrimpf.

*Neue Wilden_*Term used in Germany for Neo-
Expressionism. The Neue Wilden (i.e. new Fauves)
included two artists who became major international
figures, Georg Baselitz and Anselm Kiefer.

*New British Sculpture_*Around 1980 there can be
seen to have been a general reaction in Western art to
the predominance of Minimal and Conceptual art in
the previous decade. In painting this reaction took the
form of Neo-Expressionism and related phenomena. In
sculpture there was a notable return to the use of a wide
range of techniques of fabrication and even the use of
traditional materials and methods such as carving in
stone and marble. Figurative and metaphoric imagery
reappeared together with poetic or evocative titles. In
Britain a strong group of young sculptors emerged
whose work, although quite disparate, quickly became
known as New British Sculpture. The principal artists
associated with New British Sculpture were Stephen
Cox, Tony Cragg, Barry Flanagan, Anthony Gormley,
Richard Deacon, Shirazeh Houshiary, Anish Kapoor,
Alison Wilding and Bill Woodrow.

*New English Art Club_*Founded in London in
1886 as an exhibiting society by artists influenced
by Impressionism and whose work was rejected by
the conservative Royal Academy. Key early members
were J.A.M. Whistler (although he soon resigned),
Walter Sickert and Philip Steer. Others in the first show
included George Clausen, Stanhope Forbes and John

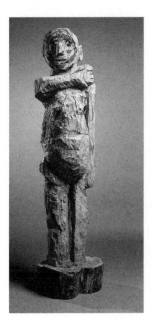

Neue Wilden
Georg Baselitz
Untitled 1982–3
Painted wood (lime)
250 x 73 x 59
Tate. Acquired by purchase and
gift from Hartmut and Silvia
Ackermeier, Berlin 1993

Singer Sargent. Initially avant-garde, the NEAC quickly
became increasingly conservative and Sickert and Steer
formed an 'Impressionist nucleus' within it, staging
their own show *London Impressionists* in 1889. NEAC
remained important as a showcase for advanced art,
until 1911 when challenged by the Camden Town Group
and London Group, and continued to be influential
into the 1920s with artists such as Augustus John
and Stanley Spencer exhibiting. It still exists, now
preserving the Impressionist tradition.

*New Generation sculpture*_New Generation
was the title used for a series of exhibitions of painting
and sculpture by young British artists held at the
Whitechapel Gallery in London in the early 1960s. The
1965 show was devoted to sculpture and brought to
wide public attention the work of Phillip King, together
with David Annesley, Michael Bolus, Tim Scott, William
Tucker and Isaac Witkin. All these artists had been
taught by Anthony Caro at St Martin's School of Art
in London and are sometimes referred to as School of
Caro as well as the New Generation sculptors. In 1960
Caro had developed a completely new form of abstract
sculpture using steel beams, sheets and tubes, welded
and bolted together and painted in bright industrial
colours. King and the others soon developed their own
work, exploring a basic vocabulary of sculptural form
and using in addition materials such as plastic sheeting
and fibreglass. New Generation sculpture became a
major phenomenon of British art in the 1960s.

*new media*_A term used to describe the sophisticated
technologies that have become available to artists since
the late 1980s. New media defines the mass influx of
media, from the CD-ROM, to the mobile phone and the
World Wide Web, that can enable the production and
distribution of art digitally. Websites like MySpace and
YouTube are key aspects of new media, being places

that can distribute art to millions of people at the click of a button.

(See also browser art; medium; net art; software art)

*New Objectivity_*see Neue Sachlichkeit

*New Spirit painting_*Virtually synonymous with Neo-Expressionism and its sub groups of Neue Wilden and Transavanguardia. *A New Spirit in Painting* was the title of a major exhibition at the Royal Academy in London in 1981. It attempted to sum up the state of painting at that point. It was an early response to the new currents that appeared in both painting and sculpture around 1980, and acted as a launchpad that brought these developments to public attention. The term New Spirit painting became used particularly in Britain, and is useful in that it also embraces aspects of new painting at that time that do not fit quite

New Spirit painting
Paula Rego
The Dance 1988
Acrylic on paper laid on canvas
212.6 x 274
Tate. Purchased 1989

comfortably into the category of Neo-Expressionism, such as the American painters David Salle and Eric Fischl and in Britain Paula Rego, Stephen McKenna, Stephen Campbell or the abstract painter Sean Scully. In Britain particularly, the renewal of interest in painting in the early 1980s, especially figurative painting, brought into fresh focus the work of older artists such as Howard Hodgkin as well as those often called the School of London.

*New York School*_This term seems to have come into use in the 1940s to describe the artists of the intensely creative and innovative New York art scene that was giving birth to the radical and world-conquering new style of painting that in the early 1950s became known as Abstract Expressionism. The two terms are effectively interchangeable, that is the artists of the New York School are the Abstract Expressionists. New York School has echoes of School of Paris and may also be seen to reflect the notion that after the Second World War, New York took over from Paris as the world centre for innovation in modern art.

*Newlyn School*_Following the extension of the Great Western Railway to West Cornwall in 1877 the Cornish fishing towns of St Ives and Newlyn both began to attract artists, drawn by the beauty of the scenery, quality of light, simplicity of life and drama of the sea. The artists known as the Newlyn School were led by Stanhope Forbes and Frank Bramley who settled there in the early 1880s. Newlyn painting combined the Impressionist-derived doctrine of working directly from the subject and, where appropriate, in the open air (see plein air), with subject matter drawn from rural life, particularly the life of the fishermen. Forbes's *The Health of the Bride* and Bramley's *A Hopeless Dawn* are quintessential Newlyn masterpieces.
(See also St Ives School)

*non-objective art*_The Russian Constructivist painters Wassily Kandinsky and Kasimir Malevich and the sculptor Naum Gabo were pioneers of non-objective art. It defines a type of abstract art that is usually, but not always, geometric and was inspired by the Greek philosopher Plato who believed that geometry was the highest form of beauty. Non-objective art may attempt to visualise the spiritual, and can be seen as carrying a moral dimension, standing for virtues like purity and simplicity. In the 1960s a group of American artists, including Sol LeWitt and Donald Judd, embraced the philosophy of non-objective art. By creating highly simplified geometric art out of industrial materials they elevated these to an aesthetic level. Their work became known as Minimal art.

*Nouveau Réalisme*_French movement (meaning new realism) founded in 1960 by the critic Pierre Restany. It was the focus for developments that can be seen as the European counterpart to Pop art. As well as painting, Nouveau Réalistes made extensive use of collage and assemblage, using real objects incorporated directly into the work and acknowledging a debt to the readymades of Marcel Duchamp. The leading exponents of this aspect were Arman, César, Christo, Jean Tinguely and Daniel Spoerri. Raymond Hains, Mimmo Rotella, Jacques Mahé de la Villeglé and Wolf Vostell developed the décollage technique, making striking works from accumulated layers of posters they removed from advertising hoardings. Among the painters were Valerio Adami, Alain Jacquet, Martial Raysse (who also made notable installations) and the German, Gerhard Richter, who named his work Capitalist Realism. One of the most significant artists associated with Nouveau Réalisme was Yves Klein who died prematurely in 1962. He was enormously inventive in his short career, staging happenings and carrying out early examples of

Nouveau Réalisme

Arman (Armand Fernandez)
Condition of Woman I 1960
Mixed media, metal, wood and glass
192 x 46.2 x 32
Tate. Purchased 1982

Performance art using his own body, and anticipating
Conceptual art as well as making remarkable paintings.

*Novecento Italiano*_Italian group formed in 1922
by Achille Funi, Mario Sironi, Carlo Carrà and others.
It was officially launched in 1923 at a meeting in Milan,
with Mussolini, the founder of the Italian Fascist Party
who, in 1922, seized power to become dictator of Italy,
as one of the speakers. After being represented at
the Venice Biennale of 1924 the group split and was
re-formed. The new Novecento Italiano staged its first
group exhibition in Milan in 1926. The group's aim was
to revive the tradition of large-format history painting in
the classical manner. The group supported fascism and
its work became associated with the state propaganda
department.

*Objective Abstraction*_Name of a style of <u>abstract art</u> developed by a group of British artists in 1933. An exhibition titled *Objective Abstraction* was held in 1934 at the Zwemmer Gallery in London. The artists involved included Graham Bell, William Coldstream, Rodrigo Moynihan and Geoffrey Tibble, and the exhibition was organised by Moynihan. Not included in this show but an important practitioner was Edgar Hubert. On the other hand, works by non-Objective Abstraction artists Ivon Hitchens, Victor Pasmore and Ceri Richards were added to the show by the gallery's director. Objective Abstraction was a non-geometric form of abstract art in which the <u>painting</u> evolved in an improvisatory way from freely applied brushstrokes. Moynihan was inspired by the <u>brushwork</u> in the late paintings of J.M.W. Turner and Claude Monet. Objective Abstraction was part of the general ferment of exploration of abstraction in Britain in the early 1930s and was short-lived. A few years later many of these artists became members of the <u>realist</u> <u>Euston Road School</u>.

*offset lithography*_see <u>lithography</u>

*oil paint*_A dispersion of pigments in a drying oil that forms a tough, coloured film on exposure to air. The drying oil is a vegetable oil, often made by crushing nuts or seeds. For paints, linseed oil is most commonly used, but poppy, sunflower, safflower, soya bean and walnut oils have also been used. Drying oils initially cure through oxidation, leading to cross-linking of the molecular chains; this is a slow process affected by film thickness and paint components. Artists have used turpentine or mineral spirits to dilute oil paint. A heavily diluted layer dries relatively quickly, being tack-free in a few days. Thicker layers, containing more oil, take longer. Oil paint continues to dry, getting harder with age over many decades. Pigments and extenders will also affect the rate of drying, so different colours may dry at different speeds.

Op art
Victor Vasarely
Supernovae 1959–61
Oil on canvas
241.9 x 152.4
Tate. Purchased 1964

*Op art*_A major development in the 1960s of <u>painting</u> that created optical effects for the spectator. These effects ranged from the subtle to the disturbing and disorienting. Op painting used a framework of purely geometric forms as the basis for its effects and also drew on colour theory and the physiology and psychology of perception. Leading figures were Bridget Riley, Jesus Raphael Soto and Victor Vasarely. Vasarely was one of the originators of Op art. Soto's work often involves mobile elements and points up the close connection between <u>kinetic</u> and Op art.

*Orphism*_Sometimes called Orphic <u>Cubism</u>. The term was coined about 1912–13 by the French poet and art critic Guillaume Apollinaire. He used it to describe the Cubist-influenced work of Robert Delaunay and his wife Sonia, and to distinguish their very <u>abstract</u> and colourful work from Cubism generally. The name comes from the legendary ancient Greek poet and musician Orpheus. Its use by Apollinaire relates to the idea that <u>painting</u> should be like music, which was an important element in the development of abstract art. In the Delaunays's work patches of subtle and beautiful colour are brought together to create harmonious <u>compositions</u>. Delaunay himself used the term <u>simultanism</u> to describe his work.

*outsider art*_Sometimes called <u>Art Brut</u>, outsider art is used to describe art that has a <u>naïve</u> quality, often produced by people who have not trained as artists or are not commonly associated with the production of art. Children, psychiatric patients and prisoners fall into this category. In 1946 the French artist Jean Dubuffet started to collect artworks he considered to be free from societal constraints. This was termed Art Brut (raw art) and in 1948 he founded the Compagnie de L'Art Brut with André Breton. The artist Ben Nicholson discovered the naïve painter Alfred Wallis in St Ives in the 1920s. A retired fisherman, Wallis painted pictures of ships and the town harbour on pieces of driftwood and cardboard.

*painterly*_see impasto

*painting*_What we call art in all its forms – painting, sculpture, drawing and engraving – appeared in human groups all over the world in the period known as the Upper Paleolithic, which is roughly from 40,000 to 10,000 years ago. Since then painting has changed in essence very little. Supports evolved from rock faces, through the walls of buildings, to portable ones of paper, wood, and finally cloth, particularly canvas. The range of pigments expanded through a wide range of earths and minerals, to plant extracts and modern synthetic colours. Pigments have been mixed with water and gum to make paint, but in the fifteenth century in Europe the innovation of using oil (linseed) produced a newly flexible and durable medium that played a major part in the explosion of creativity in Western painting at the Renaissance and after. At the same time subject matter expanded to embrace almost every aspect of life (genres).

*palette*_A smooth, flat surface on which artists set out and mix their colours before painting, which is often designed to be held in the hand. The term also refers to the range of colours habitually used by and characteristic of an artist. A palette in computer graphics is a chosen set of colours that are each assigned a number, and it is this number that determines the colour of the pixel.

*panel*_A rigid support for painting onto, traditionally made of joined planks of wood, but more recently boards and composites.

*paper*_Matted plant fibres made into sheet form either by hand (traditional) or machine (modern). Handmade paper was produced by drying pulp, produced from beating cotton or linen rags in water, on wire trays.

The lines of thinner paper produced by these wires are visible in 'laid' paper. 'Wove' paper, developed in the mid-eighteenth century, is made from trays with a tightly woven wire mesh, which leave a smoother surface and no visible lines. Artists use both handmade and machine-made paper, although handmade is often used for printmaking. Paper is traditionally said to have been invented in China in the second century AD, but was not made in Europe until the twelfth century.

*papier collé*_Papier collé (pasted paper) is a specific form of collage that is closer to drawing than painting. The Cubist painter Georges Braque first used it when he drew on imitation wood-grain paper that had been pasted onto white paper. Both Braque and Pablo Picasso made a number of papiers collés in the last three months of 1912 and in early 1913, with Picasso substituting the wood-grain paper favoured by Braque with pages from the newspaper *Le Journal* in an attempt to introduce the reality of everyday life into the pictures. Picasso also developed the idea of the papier collé into a three-dimensional assemblage when he made *Guitar* in 1912.

*parchment*_see vellum

*pastel*_Powdered pigments mixed with a small amount of binding medium to produce dry coloured sticks. Chalk can be added to soften intense pigments and to obtain a range of hues.

*patina*_Usually refers to a distinct green or brown surface-layer on bronze sculpture. Patina can be created naturally by the oxidising effect of the atmosphere or weather, or artificially by the application of chemicals. Almost all bronze sculpture has been patinated one way or the other but Constantin Brancusi polished his bronzes to reveal the beautiful natural gold colour of the metal.

Performance art

Bruce Nauman
A
from *Studies for Holograms (a-e)*
1970
Screenprint on paper
51.7 x 66.2
Tate. Purchased 1994

*pen and ink*_Historically, <u>drawings</u> have been made by applying <u>ink</u> with a quill pen made by cutting the hollow stem of a large feather, from a bird such as a goose or a swan, to create a nib. Hollow reeds were also cut in the same way and used for writing and drawing. Metal pens succeeded the quill during the nineteenth century. Pen and ink is often used in conjunction with other techniques such as washes.

*pencil*_see <u>graphite</u>

*Penwith Society of Arts*_Artists society formed in 1948 at St Ives, Cornwall, Britain. It is part of the history of the development of modern and abstract art within the artists' colony of St Ives. The Penwith Society was formed by abstract artists breaking away from the St Ives Society of Artists, which was too conservative for them. They had already formed the splinter Crypt Group within the St Ives Society, but by 1988 felt the need

for complete separation. The founders of the Penwith Society were Barbara Hepworth and Ben Nicholson together with the rest of the Crypt Group, including Peter Lanyon, who played a prominent role. They invited the eminent critic and supporter of modern art, Herbert Read, to be their president.
(See also Newlyn School)

*Performance art_*Art in which the medium is the artist's own body and the artwork takes the form of actions performed by the artist. Performance art has origins in Futurism and Dada, but became a major phenomenon in the 1960s and 1970s and can be seen as a branch of Conceptual art. In Germany and Austria it was known as Actionism. An important influence on the emergence of Performance art was the photographs of the Abstract Expressionist painter Jackson Pollock making his so-called action paintings, taken in 1950 by the photographer Hans Namuth. Performance art had its immediate origins in the more overtly theatrical happenings organised by Allan Kaprow and others in New York in the late 1950s. By the mid-1960s this theatrical element was being stripped out by early Performance artists such as Vito Acconci and Bruce Nauman. In Europe, the German artist Joseph Beuys was a hugely influential pioneer of Performance art, making a wide impact with his 'actions' from 1963 on. These were powerful expressions of the pain of human existence, and complex allegories of social and political issues and man's relationship to nature. In Britain the artist duo Gilbert & George made highly original Performance works from 1969. A major problem for early Performance artists was the ephemeral nature of the medium. Right from the start performance pieces were recorded in photography, film and video, and these eventually became the primary means by which Performance reached a wide public.

*perspective*_A system for representing objects in three-dimensional space (i.e. for representing the visible world) on the two-dimensional surface of a picture. Basic or linear perspective was invented in Italy in the early fifteenth century and first developed by the painter Paolo Uccello. Perspective rests on the fact that although parallel lines never meet, they appear to do so as they get further away from the viewer towards the horizon, where they disappear. The sides of a road, or later, railway lines, are obvious examples. In painting all parallel lines, such as the roof line and base line of a building, are drawn so as to meet at the horizon if they were extended. This creates the illusion of distance, and the point at which the lines meet is called the vanishing point. Things look smaller the further away they are, and perspective enabled painters accurately and consistently to calculate the size things should be in relation to their supposed distance from the viewpoint. Early perspective systems used a single fixed viewpoint with a single vanishing point. Later, multiple vanishing points were introduced which enabled a much more naturalistic representation of a scene to be made, because it was closer to the way we actually see, that is, from two eyes which are in constant motion. Atmospheric or aerial perspective creates the sense of distance in a painting by utilising the fact that the atmosphere appears more blue in the distance.

*photogram*_see rayograph

*photograph*_An image created by the action of light on a light-sensitive material at some stage during its making. It can be either a positive or negative image and made using one of many processes.

*photomontage*_A collage constructed from photographs that has often been used as a means of expressing political dissent. First used by the Dadaists

in 1915 in their protests against the First World War, it was later adopted by the Surrealists who exploited the possibilities photomontage offered by using free association to bring together widely disparate images, to reflect the workings of the unconscious mind. In 1923 the Russian Constructivist Aleksander Rodchenko began experimenting with photomontage as a way of creating striking socially engaged imagery concerned with the placement and movement of objects in space. Other key exponents of the medium are John Heartfield, the German artist who reconstructed images from the media to protest against Germany's Fascist regime, and Peter Kennard, whose photomontages explored issues such as economic inequality, police brutality and the nuclear arms race between the 1970s and the 1990s.

*photorealism*_A style of painting that emerged in Europe and the USA in the late 1960s, photorealism was characterised by its painstaking detail and precision. It rejected the painterly qualities by which individual artists could be recognised, and instead strove to create pictures that looked photographic. Visual complexity, heightened clarity and a desire to be emotionally neutral led to banal subject matter that likened the movement to Pop art. Artists associated with photorealism include the painter Chuck Close and Richard Estes. The early 1990s saw a renewed interest in photorealism, thanks to new technology in the form of cameras and digital equipment, which offered more precision. Younger artists practising this technique today include Raphaella Spence, Clive Head and Bertrand Meniel.
(See also Hyper-Realism)

*The Photo-Secession*_Founded by Alfred Stieglitz in New York in 1902, The Photo-Secession was a group of American photographers who believed that photography was a fine art. The name was invented by Stieglitz as a

way of affiliating the photographers with the <u>modernist</u> <u>Secession</u> movements in Europe. The other members were Alvin Langdon Coburn, Gertrude Käsebier, Edward Steichen and Clarence H. White, who all placed great influence on fine photographic printing and used techniques to emulate paint and pastel. The results were printed in their magazine *Camera Work* that Stieglitz edited from 1903 to 1907, and exhibited in their gallery, The Little Galleries of the Photo-Secession, later known simply as 291.

*picture plane*_In traditional <u>illusionistic</u> <u>painting</u> using <u>perspective</u>, the picture plane can be thought of as the glass of the notional window through which the viewer looks into the representation of reality that lies beyond. In practice the picture plane is the same as the actual physical surface of the painting. In modern art the picture plane became a major issue. <u>Formalist</u> theory asserts that a painting is a flat object and that in the interests of truth it should not pretend to be other than flat. In other words, there should be no illusion of three dimensions and so all the elements of the painting should be located on the picture plane.

*Pittura Metafisica*_Italian art movement, 'Metaphysical art'. Created by Giorgio de Chirico and the former <u>Futurist</u>, Carlo Carrà, in the north Italian city of Ferrara. Using a <u>realist</u> style, they painted dream-like views of the arcaded squares typical of such Italian cities. The squares are unnaturally empty, and in them objects and statues are brought together in strange juxtapositions. The artists thus created a visionary world of the mind, beyond physical reality, hence the name. Strictly speaking the movement only lasted around six months in 1917 while de Chirico and Carrà worked together, de Chirico changing his style the following year. However, the term is generally applied to all de Chirico's work from about 1911 when

he first developed what became known as Pittura Metafisica. His *The Uncertainty of the Poet* of 1913 is a quintessential example of the style. Pittura Metafisica was also highly influential, most importantly on the development of the dream-like, or oneiric, kind of Surrealist painting, particularly that of Max Ernst.

*plane*_A plane is a flat surface, and any discrete flat surface within a painting or sculpture can be referred to as a plane. The flat patches seen in Cubist paintings are often referred to as planes, and geometric abstract artists refer frequently to planes in discussing their work.

*Plaster of Paris*_A fine white powder (calcium sulphate hemihydrate) which, when mixed with water, forms fully hydrated calcium sulphate, a white solid. Widely used by sculptors for moulds and preliminary casts.

*plein air*_French term meaning 'out of doors', this refers to the practice of painting an entire finished picture out of doors as opposed to simply making preparatory studies or sketches. It was pioneered by John Constable in Britain c.1813–17, then from c.1860 became fundamental to Impressionism. An important technical approach in the development of naturalism, it subsequently became extremely widespread and part of the practice of rural naturalists, for example. It was sometimes taken to extremes: there exists a photograph of Stanhope Forbes painting on a beach in high wind, with his canvas and easel secured by guy ropes.

*pluralism*_Refers to a social structure in which many small groups maintain their unique cultural identity within a broader culture. In an art context, pluralism refers to the late 1960s and 1970s when art, politics and culture merged as artists began to believe in a more socially and politically responsive form of art. The art

historian Rosalind Krauss characterised this period as 'diversified, split and factionalized. Unlike the art of the last several decades, its energy does not seem to flow through a single channel for which a synthetic term, like Abstract Expressionism, or Minimalism, might be found.'

*polyptych*_A painting made up of more than three panels. Paintings of three panels are triptychs and of two, diptychs.

*Pont-Aven*_The coastal town in north-west France which Paul Gauguin frequented between 1886 and 1894. With a group that included Emile Bernard and Paul Sérusier he developed a Synthetic style of painting that emphasised, through bold outline and simplified structure, a symbolic and emotional response to the Breton people and landscape.
(See also synthetism)

*Pop art*_Name given to British and American versions of art that drew inspiration from sources in popular and commercial culture. These sources included Hollywood movies, advertising, packaging, pop music and comic books. In Europe a similar movement was called Nouveau Réalisme (New Realism). Pop began in the mid-1950s and reached its peak in the 1960s. It was a revolt against prevailing orthodoxies in art and life and can be seen as one of the first manifestations of Postmodernism. Modernist critics were horrified by the Pop artists' use of such low subject matter and by their apparently uncritical treatment of it. In fact, Pop took art into new areas of subject matter and developed new ways of presenting it in art. Chief artists in America were Roy Lichtenstein, Claes Oldenburg and Andy Warhol; in Britain, Peter Blake, Patrick Caulfield, Richard Hamilton, David Hockney, Allen Jones and Colin Self.

Pop art
Claes Oldenburg
Soft Drainpipe – Blue (Cool) Version
1967
Acrylic on canvas and steel
259.1 x 187.6 x 35.6
Tate. Purchased 1970

*portfolio*_A group of <u>prints</u>, often – though not necessarily – by the same artist and presented as a group, usually based on a related theme. Sometimes they will be considered as a set or series of images. The term also applies to the physical folder in which such series may be held.

*portrait*_A <u>representation</u> of a particular person. Portraiture is a very old art form going back at least to ancient Egypt, where it flourished from about 5,000 years ago. Before the invention of <u>photography</u>, a painted,

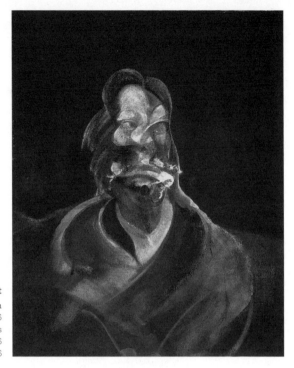

Francis Bacon
Portrait of Isabel Rawsthorne 1966
Oil on canvas
81.3 x 68.6
Tate. Purchased 1966

sculpted or drawn portrait was the only way to record
the appearance of someone. But portraits have always
been more than just a record. They have been used to
show the power, importance, virtue, beauty, wealth, taste,
learning or other qualities of the sitter. Portraits have
almost always been flattering, and painters who refused
to flatter, such as William Hogarth, tended to find
their work rejected. A notable exception was Francisco
Goya in his apparently bluntly truthful portraits of the
Spanish royal family. Among leading modern artists,
portrait painting on commission became increasingly
rare. Instead artists painted their friends and lovers
in whatever way they pleased. Most of Pablo Picasso's
pictures of women, for example, however bizarre, can
be identified as portraits of his lovers. At the same time,
photography became the most important medium of
traditional portraiture, bringing what was formerly an
expensive luxury product within the purse of almost

everyone. Since the 1990s artists have also used video to create living portraits, but portrait painting continues to flourish.
(See also <u>conversation piece</u>; <u>genres</u>)

*postcolonial art*_Art produced in response to the aftermath of colonial rule, frequently addressing issues of national and cultural identity, race and ethnicity. Frantz Fanon provided a theoretical framework for interpreting the oppression of the individual under imperialism – a significant element of much postcolonial art – and initiated the investigation of diversity and hierarchy in postcolonial cultures undertaken by writers such as Edward Said, Stuart Hall and Homi Bhabha.

*Post-Impressionism*_Umbrella term to describe changes in <u>Impressionism</u> from about 1886, the date of the last Impressionist group show in Paris. There were four major figures who developed and extended Impressionism in distinctly different directions. Paul Cézanne retained the fundamental doctrine of <u>painting</u> from nature but with added rigour, reportedly saying 'I want to re-do Poussin from nature' (Gaspard Poussin was a notoriously intellectual pioneer of French <u>landscape</u>). Georges Seurat put Impressionist painting of light and colour on a scientific basis (<u>Neo-Impressionism</u>, divisionism). Paul Gauguin retained intense light and colour but rejected painting from nature and reintroduced imaginative subject matter. Vincent van Gogh painted from nature but developed a highly personal use of colour and <u>brushwork</u>, directly expressing an emotional response to the subject and his inner world.

*Postmodernism*_Term used from about 1970 to describe changes seen to take place in Western society and culture from the 1960s onwards. These changes arose from anti-authoritarian challenges to the prevailing

Postmodernism

Gilbert & George
Death Hope Life Fear 1984
First panel of a quadripartite picture
Mixed media
423 x 252
Tate. Purchased 1990

orthodoxies across the board. In art, Postmodernism
was specifically a reaction against <u>modernism</u>. It may be
said to begin with <u>Pop art</u> and to embrace much of what
followed including <u>Conceptual art</u>, <u>Neo-Expressionism</u>,
<u>feminist art</u>, and the <u>Young British Artists</u> of the 1990s.
Some outstanding characteristics of Postmodernism are
that it collapses the distinction between high culture
and mass or popular culture; that it tends to efface the
boundary between art and everyday life; and that it
refuses to recognise the authority of any single style or
definition of what art should be.

*Post-Painterly Abstraction*_A blanket term
covering a range of new developments in abstract
painting in the late 1950s and early 1960s. In 1964 an
exhibition of thirty-one artists associated with these
developments was organised by the critic Clement
Greenberg at the Los Angeles County Museum of Art.
He titled it *Post-Painterly Abstraction*. Leading figures
were Helen Frankenthaler, Morris Louis and Kenneth
Noland. Post-Painterly Abstraction set abstract painting
on a more rigorous, i.e. more purely abstract, basis
than before. It grew very directly out of the existing
traditions of abstract art, synthesising elements from
Jackson Pollock, Mark Rothko and Barnett Newman
as well as looking to Ad Reinhardt and Ellsworth Kelly,
to the late work of Henri Matisse and to the targets
and flags of Jasper Johns. However, the Post-Painterly
Abstractionists were ruthless in their rejection of the
inwardness and mysticism of Abstract Expressionism
and of any residual references to the external world, and
they also explored new ways of composing. What they
created was a purely factual kind of art which, more than
ever before, functioned in terms of the basic elements
of the medium itself; form, colour, texture, scale,
composition and so on.

*primitivism*_Term used to describe the fascination of
early modern European artists with what was then called
primitive art. This included tribal art from Africa, the
South Pacific and Indonesia, as well as prehistoric and
very early European art, and European folk art. Such work
has had a profound impact on modern Western art. The
discovery of African tribal art by Pablo Picasso around
1906 was an important influence on his painting in
general, and was a major factor in leading him to Cubism.
Primitivism also means the search for a simpler more
basic way of life away from Western urban sophistication
and social restrictions. The classic example of this is
Paul Gauguin's move from Paris to Tahiti in the South

Pacific in 1891. Primitivism was also important for Expressionism, including Die Brücke. As a result of these artists' interest and appreciation, what was once called primitive art is now seen as having equal value to Western forms and the term primitive is avoided or used in quotation marks.

*print*_An impression made by any method involving transfer from one surface to another.

*process art*_Art in which the process of its making is not hidden but remains a prominent aspect of the completed work, so that a part or even the whole of its subject is the making of the work. Process became a widespread preoccupation of artists in the late 1960s and the 1970s, but like so much else can be tracked back to the Abstract Expressionist paintings of Jackson Pollock. In these, the successive layers of dripped and poured paint can be identified and the actions of the artist in making the work can be to some extent reconstructed. The later Colour Field paintings of Morris Louis clearly reveal his process of pouring the paint onto the canvas. In process art too there is an emphasis on the results on particular materials of carrying out the process determined by the artist. In Louis again, the forms are the result of the interaction of the artist's action, the type and viscosity of the paint, and the type and absorbency of the canvas. Richard Serra made work by throwing molten lead into the corners of a room, and Robert Morris by making long cuts into lengths of felt and then hanging them on a nail or placing them on the floor and allowing them to take on whatever configurations were dictated by the interaction of the innate properties of the felt, the artist's action and gravity. The British painter Bernard Cohen made paintings by establishing a set process for the work and then carrying it through until the canvas was full. John Hilliard's photographic work *Camera Recording its Own Condition* of 1971 is a

particularly pure example of process art, as is Michael Craig-Martin's *4 Complete Clipboard Sets.*

*proof_*A printing term applied to all individual impressions made before work on a printing plate or block is completed, in order to check progress of the image. Also referred to as 'trial proof' or 'colour trial proof'. This should not be confused with the terms Artist's Proof (AP) and Printer's Proof (PP), which are impressions of the finished print made in addition to the published edition for the artist or printer.

*proportion_*The relationship of one part of a whole to other parts. In art it has usually meant a preoccupation with finding a mathematical formula for the perfect human body. At the time of the Renaissance, Leonardo da Vinci and Albrecht Dürer attempted to find a formula that would enable the body to be exactly inscribed in a square or a circle. Their system seems to have been to first make the height the same as the full width of the outstretched arms, and then to add to the height so that the total height was equal to eight heads. Renaissance researches into proportion were inspired by the ancient Roman writer of a treatise on architecture, Vitruvius. A more general formula for perfect proportion is the golden section or golden ratio. This is defined as a line divided so that the smaller part is to the larger part as the larger part is to the whole. It works out at roughly 8:13 or a bit over one third to two thirds. In one way or another the golden section can be detected in most works of art. It so named because it was considered to have some special aesthetic virtue in itself.

*provenance_*A history of ownership of a work of art. The word comes from the French verb *provenir* (to come from). Provenance is essential in identifying, with certainty, the authorship of a work of art. When the chips are down, no amount of connoisseurship can beat a good

provenance. The ideal provenance would consist of a history of ownership traceable right back to the artist's studio. Another important aspect of the history of an artwork is the exhibitions it has been in. The importance of provenance has not escaped the attention of forgers (see fake). In the 1990s a forger inserted fake references to forged paintings into material such as exhibition catalogues in museum archives. This convinced buyers even when the quality of the forgery was not especially good.

psychedelic art_Generally associated with the 1960s and the mind-expanding drug LSD. There are many earlier examples of artists taking drugs in order to heighten their awareness and enlarge their mental vision, but it was the hallucinatory effects of LSD that had such a powerful effect on artists. Day-glo and anti-naturalistic in colour, psychedelic art often contained swirling patterns, erotic imagery and hidden messages, all aiming to refer to the changing states of consciousness while under the influence of the drug. Much of the art grew out of the hippy community in San Francisco, in particular the artists Stanley Mouse, Rick Griffin and Alton Kelley who were commissioned by the rock promoter Bill Graham to produce posters for the bands The Grateful Dead, Jimi Hendrix and The Big Brother Holding Company.

public art_Artwork that is in the public realm, regardless of whether it is situated on public or private property or whether it has been purchased with public or private money. Usually, but not always, the art has been commissioned specifically for the site in which it is situated (site-specific). Monuments, memorials and civic statues and sculptures are the most established forms of public art, but public art can also be transitory, in the form of performances, dance, theatre, poetry, graffiti, posters, street art and installations. Public art

can often be used as a political tool, like the propaganda posters and statues of the Soviet Union (Agit-prop) or the murals painted by the Ulster Unionists in Northern Ireland. Public art can also be a form of civic protest, as in the graffiti sprayed on the sides of New York Subway trains in the 1980s.
(See also Mexican Muralism)

*Purism_*Movement founded by Edouard Jeanneret (better known as the modern architect Le Corbusier) and Amédée Ozenfant. They set out the theory of Purism in their book *Après le Cubisme* (After Cubism) published in 1918. They criticised the fragmentation of the object in Cubism and the way in which Cubism had become, in their view, decorative by that time. Instead they proposed a kind of painting in which objects were represented as powerful basic forms stripped of detail. A crucial element of Purism was its embrace of technology and the machine, and it aimed to give mechanical and industrial subject matter a timeless, classical quality. References to ancient Greek architecture can be seen in the fluting (like a Greek column) on the bottles in Ozenfant's still life compositions. The most important other artist associated with Purism was Fernand Léger. Purism reached a climax in Le Corbusier's Pavillon de l'Esprit Nouveau (Pavilion of the New Spirit), built in 1925 for the International Exposition of Decorative and Industrial Arts in Paris. This was hung with work by the three principals and also included the Cubists, Juan Gris and Jacques Lipschitz. After this the key relationship between Ozenfant and Le Corbusier broke up.

*queer aesthetics*_Art of homosexual or lesbian imagery that is based around the issues that evolved out of the gender and identity politics of the 1980s. Although there have been many representations of homosexuality and lesbianism in the history of art, it was in the 1980s, in the wake of the feminist movement and the AIDS crisis, that the queer aesthetic was born. Artists began to document a cultural landscape that was rapidly disappearing, as well as the backlash that had taken place against sexual freedom. Much of the art resonates with themes of life and death, in particular the photographs of Nan Goldin and Wolfgang Tillmans and the installations of Felix Gonzalez-Torres. There is also a critical exploration of representation, as in the photographs of lesbians by Catherine Opie and in the studies of the gay S&M scene in New York by Robert Mapplethorpe.
(See also feminist art)

*rayograph*_Photograms are <u>photographic</u> prints that do not require the use of a camera and are made by laying objects directly onto photosensitive paper and exposing it to light. The process is as old as photography itself, but emerged again in various <u>avant-garde</u> contexts in the early 1920s. Man Ray refined and personalised the technique to such an extent that the new prints eventually carried his name – rayographs.

*Rayonism*_One of the Russian <u>avant-garde</u> movements that proliferated in Moscow and St Petersburg in the from about 1910 to 1920. Rayonism, or Rayism, was the invention of Mikhail Larionov and his partner Natalia Goncharova in 1912. It was an early form of <u>abstract art</u>, based on <u>landscape</u> and consisting of dynamically interacting linear <u>forms</u> ultimately derived from rays of light. Of his Rayonist <u>painting</u> *Nocturne* Larionov later wrote: 'This painting was inspired by the dusk at Odessa. It is a problem of the combination of staircases, interiors and exteriors of houses and represents the pressure of the body of dark colours on the semi-light <u>tones</u>. The problem of this painting is to organise these tones in a certain order. It is the conflict of the semi-light rays with the dark rays.'

*readymade*_The term used by the French artist Marcel Duchamp to describe works of art he made from manufactured objects. His earliest readymades included *Bicycle Wheel* of 1913, a wheel mounted on a wooden stool, and *In Advance of the Broken Arm* of 1915, a snow shovel inscribed with that title. In 1917 in New York, Duchamp made his most notorious readymade, *Fountain*, a men's urinal signed by the artist with a false name and exhibited laid flat on its back. Later readymades could be more elaborate and were referred to by Duchamp as assisted readymades. The theory behind the readymade was explained in an article, anonymous but almost certainly by Duchamp himself,

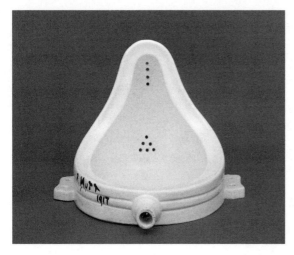

readymade
Marcel Duchamp
Fountain 1917, replica 1964
Porcelain
36 x 48 x 61
Tate. Purchased with assistance
from the Friends of the Tate Gallery
1999

in the May 1917 issue of the avant-garde magazine *The Blind Man* run by Duchamp and two friends: 'Whether Mr Mutt with his own hands made the fountain or not has no importance. He CHOSE it. He took an ordinary article of life, and placed it so that its useful significance disappeared under the new title and point of view – created a new thought for that object.' There are three important points here: first, that the choice of object is itself a creative act. Secondly, that by cancelling the 'useful' function of an object it becomes art. Thirdly, that the presentation and addition of a title to the object have given it 'a new thought', a new meaning. Duchamp's readymades also asserted the principle that what is art is defined by the artist. Duchamp was an influential figure in Dada and Surrealism, an important influence on Pop art, environments, assemblage, installation, Conceptual art and much art of the 1990s such as YBA. (See also Postmodernism)

*Realism*_Until the nineteenth century Western art was dominated by the academic theory of history painting and high art. Then, the development of naturalism began to go hand in hand with increasing emphasis on realism of subject, meaning subjects outside the high art

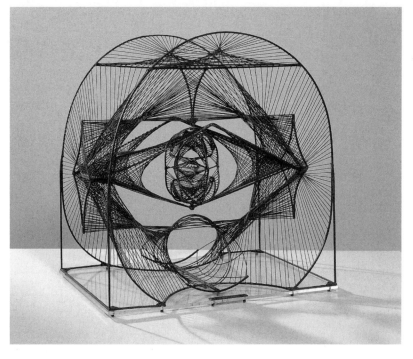

Réalités Nouvelles
Antoine Pevsner
*Maquette of a Monument
Symbolising the Liberation
of the Spirit* 1952
Bronze
47.2 x 46.5 x 31
Tate. Purchased 1953

tradition. The term Realism was coined by the French
novelist Champfleury in the 1840s and in art was
exemplified in the work of his friend, the painter Gustave
Courbet. In practice, Realist subject matter meant
scenes of peasant and working-class life, the life of the
city streets, cafés and popular entertainments, and an
increasing frankness in the treatment of the body and
sexual subjects. Such subject matter combined with the
new naturalism of treatment caused shock among the
predominantly upper- and middle-class audiences for
art.
(See also <u>Fantastic Realism</u>; <u>Hyper-Realism</u>; <u>Magic
Realism</u>; <u>Social Realism</u>; <u>Socialist Realism</u>)

*realism*_Since the rise of modern art, realism, realist or
realistic, with a lower case 'r', has come to be primarily
a stylistic description, referring to painting or sculpture
that continues to <u>represent</u> things in a way that more or

less pre-dates <u>Post-Impressionism</u>. The term generally implies a certain grittiness of choice of subject.
(See also <u>modern realism</u>; <u>photorealism</u>; <u>ugly realism</u>)

*Réalités Nouvelles_*The <u>Salon</u> des Réalités Nouvelles (new realities) was an exhibiting society devoted to pure <u>abstract art</u>, founded in Paris in 1939 by Sonia Delaunay and others. After the interruption of the Second World War it was re-established in 1946 with the help of Delaunay, and continues today. In the post-war era it provided the same focus for the purest tendencies in abstract art that <u>Abstraction-Création</u> had before the war. The name reflects the fundamental idea that abstract art is a new reality because it does not refer to or imitate any existing reality.

*recto / verso_*The recto is the front or face of a single sheet of <u>paper</u>, or the right-hand page of an open book. The back or underside of a single sheet of paper, or the left-hand page of an open book, is known as the verso.

*relational aesthetics_*The French <u>curator</u> Nicolas Bourriaud published a book called *Relational Aesthetics* in 1998 in which he described the term as meaning 'a set of artistic practices which take as their theoretical and practical point of departure the whole of human relations and their social context, rather than an independent and private space.' He saw artists as facilitators rather than makers and regarded art as information exchanged between the artist and the viewers. The artist, in this sense, gives audiences access to power and the means to change the world. Bourriaud cited the art of Gillian Wearing, Philippe Parreno, Douglas Gordon and Liam Gillick as artists who work to this agenda.

*relief_*A wall-mounted <u>sculpture</u> in which the three-dimensional elements are raised from a flat base. Any three-dimensional element attached to a basically flat

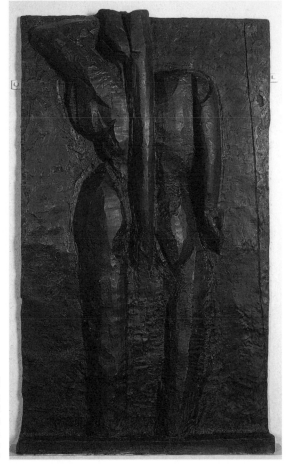

relief
Henri Matisse
Back III c.1916-17, cast 1955-6
Bronze
188 x 113 x 17.1
Tate. Purchased with assistance
from the Matisse Appeal Fund 1957

wall-mounted work of art is said to be in relief or a relief element.

*replica*_A copy of a work of art that is virtually indistinguishable from the original. Unlike a <u>fake</u>, a replica is not trying to pass for the original and is often made by the artist and used for historical and educational purposes. The vogue for collecting replicas reached the height of popularity in the mid- to late nineteenth century when few people could afford to travel on the Continent, so museums acquired

reproductions of important monuments and works of art to complement their collections. Replicas in modern art are made as a result of original works of art decaying or being lost. Marcel Duchamp's *Fountain*, the most famous of the artist's readymade sculptures, was replicated in collaboration with Duchamp from a photograph of the lost original. Tate holds the largest collection of plastic sculptures by Naum Gabo, but despite controlled storage conditions, many of these works are cracking and warping. Computer software will be used to help virtually restore the sculpture models, so that replicas can be made of the originals.
(See also simulacrum)

*representational*_A blanket term for art that represents some aspect of reality in a more or less straightforward way. The term seems to have come into use after the rise of modern art and particularly abstract art as a means of referring to art not substantially touched by modern developments. It is not quite the same as figurative art, which seems to apply to modern art in which the elements of reality, while recognisable, are nevertheless treated in modern ways, as in Expressionism for example. The term figurative also implies a particular focus on the human figure. The term non-representational is frequently used as a synonym for abstract.

*resin*_An organic solid, usually transparent. 'Natural' resins derive from either plants or insects, whereas 'synthetic' resins (for example alkyd and acrylic) are manufactured industrially. They can usually be dissolved in organic solvents to produce a clear solution, although many synthetic resins are produced as dispersions.

*'return to order'*_From the French *retour à l'ordre*, this was a phenomenon of European art in the years following the First World War. The term is said to derive

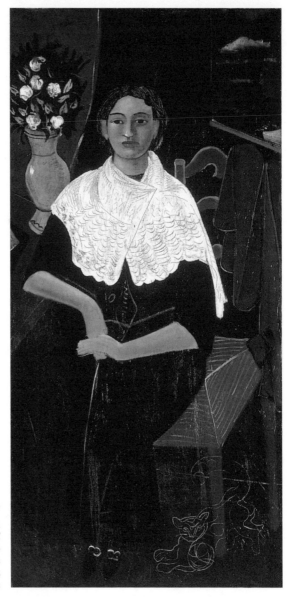

'return to order'
André Derain
Madame Derain in a White Shawl
c.1919–20
Oil on canvas
195.5 x 97.5
Tate. Purchased 1982

from the book of essays by the artist and poet Jean Cocteau, *Le rappel a l'ordre*, published in 1926. The First World War administered a huge shock to European society. One of the artistic responses to it was to

reject the extreme avant-garde forms of art that had proliferated before the war. Instead, more reassuring and traditional approaches were adopted. The term 'return to order' is used to describe this phenomenon. Cubism, with its fragmentation of reality, was rejected, even by its inventors Georges Braque and Pablo Picasso. Futurism, with its worship of the machine and its enthusiasm for war, was particularly discredited. Classicism was an important thread in the 'return to order', and in the early 1920s Picasso entered a Neoclassical phase. Braque painted calm still life and figure pictures that, while still having some Cubist characteristics, were simple and readable. The former Fauve painter André Derain and many other artists turned to various forms of realism. In Germany Neue Sachlichkeit can be seen as part of the 'return to order'.

*rural naturalism*_Paintings of rural life in a naturalist manner, but the subjects tend to be sentimentalised, distinguishing them from more gritty realist work. In Britain the style was exemplified by the Newlyn School and the work of artists such as George Clausen, Henry Herbert La Thangue and Edward Stott.

*Ruralists*_Group of British artists founded in 1975 around the Pop artist Peter Blake, after his move from London to the countryside near Bath. The full name was The Brotherhood of Ruralists and this, combined with the original number of seven members, gives a conscious echo of the nineteenth-century Pre-Raphaelite Brotherhood, which the Ruralists deeply admired. The members of the group were, in addition to Blake, Ann Arnold, Graham Arnold, Jann Haworth (Blake's then wife), David Inshaw, Annie Ovenden and Graham Ovenden. The Ruralists aimed to revive and update the vein of imaginative painting of romantic figure subjects in idyllic rural settings, in a style of high-precision realism, found in the early work of the

Pre-Raphaelites. The painting *Ophelia* by John Everett Millais was a talismanic example. They also looked to the earlier visionary <u>landscapes</u> of Samuel Palmer and the Ancients. The children's book *Alice's Adventures In Wonderland* and its illustrations by John Tenniel and Arthur Rackham were another source of inspiration. Blake, Haworth and Inshaw left the group in the early 1980s but it continues with the Arnolds and Ovendens.

*St Ives School_*Term referring to the artists associated with the fishing town of St Ives in West Cornwall, Britain. The town became a particular magnet for artists following the extension to West Cornwall of the Great Western Railway in 1877. In 1928 the artists Ben Nicholson and Christopher Wood visited St Ives where they were struck by the work of the <u>naïve</u> artist Alfred Wallis, whose <u>painting</u> confirmed Nicholson in the modern direction of his work. In 1939 at the outbreak of the Second World War, Nicholson and his then wife the <u>sculptor</u> Barbara Hepworth, both by then fully fledged <u>abstract</u> artists, settled near St Ives, where they were soon joined by the Russian <u>Constructivist</u> sculptor Naum Gabo. After the war St Ives became a centre for modern and abstract developments in British art led by Hepworth and Nicholson (Gabo departed in 1946). From about 1950 there gathered in St Ives a group of younger artists and it is with this group, together with Hepworth and Nicholson (until his departure in 1958), that the term St Ives School is particularly associated. The principal figures of the St Ives School include Wilhelmina Barns-Graham, Paul Feiler, Terry Frost, Patrick Heron, Roger Hilton, Peter Lanyon, Karl Weschke and Bryan Wynter, together with the pioneer modern potter, Bernard Leach. The heyday of the St Ives School was in the 1950s and 1960s but in 1993 Tate St Ives, a striking purpose-built new gallery in a remarkable situation on Porthmeor Beach in St Ives, was opened. It exhibits the Tate collection of St Ives School art and related types of art and has given the town a whole new lease of artistic life.

*salon_*Originally the name of the official art exhibitions organised by the French Académie Royale de Peinture et de Sculpture (Royal Academy of Painting and Sculpture) and its successor the Académie des Beaux Arts (Academy of Fine Arts). From 1725 the exhibitions were held in the room called the Salon carré in the Louvre

and became known simply as the Salon. This later gave
rise to the generic French term of 'salon' for any large
mixed art exhibition. By the mid-nineteenth century the
academies had become highly conservative, and by their
monopoly of major exhibitions resisted the rising tide of
innovation in naturalism, Realism, Impressionism and
their successors. By about 1860 the number of artists
being excluded from the official Salon became so great
and such a scandal that in 1863 the government was
forced to set up an alternative, to accommodate the
refused artists. This became known as the Salon des
refusés. Three further Salons des refusés were held in
1874, 1875 and 1886. In 1884 the Salon des Indépendents
was established by the Neo-Impressionists Georges
Seurat and Paul Signac, together with Odilon Redon, as
an alternative exhibition for innovatory or anti-academic
art. It held annual exhibitions until the start of the First
World War. In 1903 the Salon d'automne was founded,
also as an alternative exhibition for innovatory artists. It
was there that Fauvism came to public attention in 1905.
The Salon d'automne continues to be held in Paris every
year.

*sampling_*In its most basic form sampling simply
re-processes existing culture, usually technologically,
in much the same way a collage does. In the early
1980s artists began cannibalising fragments of sound,
image, music, dance and performance to create new
works of art. These hybrid projects used sampling to
generate live or time-based events that subverted our
notions of time, space, artist and audience, virtual
and actual. In the past two decades this DIY punk
aesthetic has come to represent a radical challenge to
the notions of authorship, originality and intellectual
property, while creating new narratives and refreshing
the cultural archive. Artists like Christian Marclay
and Candice Breitz manipulate film and music,
remixing familiar footage into epic narratives.

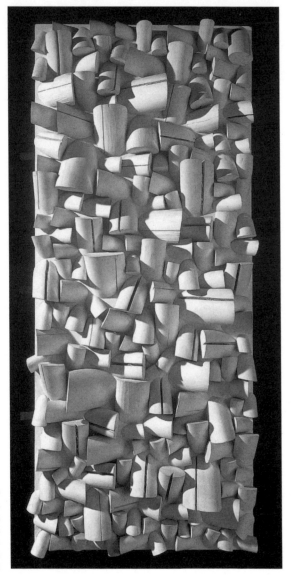

School of Altamira
Sergio de Camargo
Large Split Relief No.34/4/74 1964-5
Relief of limewood and
paint on plywood support
215.3 x 92.1 x 27.3
Tate. Purchased 1965

*São Paulo Biennal*_see <u>biennial</u>

*School of Altamira*_ <u>Avant-garde</u> art school
(Academia Altamira) in Buenos Aires, Argentina,
founded in 1946 by the Argentinian-born Italian artist

Lucio Fontana and others. Its aim was to promote the idea that a new art was necessary to reflect the modern world as revealed by science. In practice this art was abstract. Also in 1946 Fontana and a group of his students published the *Manifiesto Blanco* (white manifesto) setting out their ideas. Strongly influenced by Futurism, it called for an art that was a synthesis of colour, sound, movement, time and space. Among Fontana's pupils at the Altamira Academy was the Brazilian artist Sergio de Camargo. In 1947 Fontana returned to Italy.

*School of London*_In 1976, at the height of Minimal art and Conceptual art, the American painter R.B. Kitaj, then based in Britain, organised an exhibition titled *The Human Clay* at the Hayward Gallery, London. It exclusively consisted of figurative drawing and painting and proved highly controversial. In his catalogue text, Kitaj used the term School of London to loosely describe the artists he had brought together. The name has stuck to refer to painters at that time who were doggedly pursuing forms of figurative painting in the face of the prevailing avant-garde forms. The chief artists associated with the idea of the School of London, in addition to Kitaj himself, were Michael Andrews, Frank Auerbach, Francis Bacon, Lucian Freud, David Hockney (although living in the USA), Howard Hodgkin and Leon Kossoff. The work of these artists was brought into fresh focus and given renewed impetus by the revival of interest in figurative painting by a younger generation that took place in the late 1970s and the 1980s.
(See also Neo-Expressionism; New Spirit painting)

*School of Paris*_During the nineteenth century Paris, France, became the centre of a powerful national school of painting and sculpture, culminating in the dazzling innovations of Impressionism and Post-Impressionism.

As a result, in the early years of the twentieth century Paris became a magnet for artists from all over the world and the focus of the principal innovations of modern art, notably Fauvism, Cubism, abstract art and Surrealism. The term School of Paris grew up to describe this phenomenon. The twin chiefs (*chefs d'école*) were Pablo Picasso who settled in Paris from his native Spain in 1904, and the Frenchman Henri Matisse. Also in 1904, the pioneer modern sculptor Constantin Brancusi arrived in Paris from Romania, and in 1906 the painter and sculptor Amedeo Modigliani from Italy. Chaïm Soutine arrived from Russia in 1911. The Russian painter Marc Chagall lived in Paris from 1910 to 1914 and then again from 1923 to 1939 and 1947 to 1949, after which he moved to the South of France. The Dutch pioneer of pure abstract painting, Piet Mondrian, settled in Paris in 1920 and Wassily Kandinsky in 1933. The heyday of the School of Paris was ended by the Second World War, although the term continued to be used to describe the artists of Paris. However, from about 1950 its dominance ceded to the rise of the New York School.

School of Rome_see Scuola Romana

screenprint_A variety of stencil printing using a screen made from fabric (silk or synthetic) stretched tightly over a frame. The non-printing areas on the fabric are blocked out by a stencil, which can be created by painting on glue or lacquer, by applying adhesive film or paper, or painting a light-sensitive resist onto the screen that is then developed as a photograph (photo-screenprint). Ink or paint is forced through the open fabric with a rubber blade, known as a squeegee, onto the paper. Screenprinting has been used commercially since the 1920s and by artists since the 1950s. When it was taken up by artists in 1930s America the term 'serigraph' was used to denote an artist's print, as

opposed to commercial work. The term 'silkscreen' (silk was originally used for the mesh) was and still is used, particularly in America.

*sculpture_*A three-dimensional artwork made by one of four basic processes. These are carving (in stone, wood, ivory or bone); modelling in clay; modelling (in clay or wax) and then <u>casting</u> the model in bronze; constructing (a twentieth-century development). The earliest known human artefacts recognisable as what we would call sculpture date from the period known as the Upper Paleolithic, which is roughly from 40,000 to 10,000 years ago. These objects are small female figures with bulbous breasts and buttocks carved from stone or ivory, and are assumed to be fertility figures. The most famous of them is known as the Venus of Willendorf (the place in Austria where it was found in 1908). Sculpture flourished in ancient Egypt from about 5,000 years ago and in ancient Greece from some 2,000 years later. In Greece it reached what is considered to be a peak of perfection in the period from about 500 to 400 BC. At that time, as well as making carved sculpture, the Greeks brought the technique of casting sculpture in bronze to a high degree of sophistication. Following the fall of the Roman Empire the technique of bronze casting was almost lost but, together with carved sculpture, underwent a major revival at the Renaissance. In the twentieth century a new way of making sculpture emerged with the <u>Cubist</u> constructions of Pablo Picasso. These were <u>still life</u> subjects made from scrap (found) materials glued together. Constructed sculpture in various forms became a major stream in modern art (see <u>assemblage</u>; <u>Constructivism</u>; <u>installation</u>; <u>Minimal art</u>; <u>New Generation sculpture</u>). Techniques used included <u>welding</u> metal, introduced by Julio González, who also taught it to Picasso.

*Scuola Romana (School of Rome)*_ Umbrella term for artists based in Rome, or having close links with it, in the 1920s and 1930s. Like the School of Paris the term embraces a wide variety of types of art. However, a return to classicism was a dominant current (see 'return to order'). Major artists include Giorgio de Chirico, Giacomo Balla, Renato Guttuso, Arturo Martini, Fausto Pirandello and Gino Severini.

*Secession*_ As a general term this is used to describe the breaking away of younger and more radical artists from an existing academy or art group, to form a new grouping. The word is originally German and its earliest appearance seems to be in the name of the Munich Secession group formed in 1892. In the same year this was followed by the Berliner Secession, led by Max Liebermann and later Lovis Corinth, and in 1913 by the Freie Secession in which Max Beckmann and Ernst Barlach were involved. The most famous secession group is the Vereinigung bildener Künstler Oesterreichs (Secession) founded in 1897 and generally known simply as the Vienna Secession. It was led by one of the greatest of all symbolist painters, Gustav Klimt. In 1898 the Secession commissioned the architect Joseph Olbrich to build an exhibition hall. The result is a masterpiece of Art Nouveau architecture that remains one of the gems of Vienna. It also contains Klimt's great mural the *Beethoven Frieze*. Over following years the Vienna Secession held a series of exhibitions (several a year) that brought together a roll call of the international avant-garde. There was a particular emphasis on architecture and design, and the Vienna Secession played a major part in the broader Art Nouveau movement and the beginnings of modern design. In 1903 a design company was founded called the Wiener Werkstätte (Vienna Workshops), inspired by the English Arts and Crafts Movement. Its products are now museum pieces. Later major artists associated

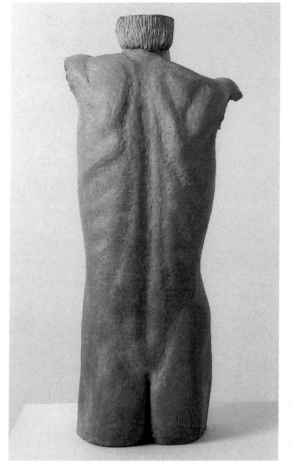

Scuola Romana
Arturo Martini
Torso of a Young Man
1928, cast 1928 or 1929
Terracotta
86 x 47 x 19
Tate. Purchased 1994

with the Vienna Secession include Egon Schiele
and Oskar Kokoschka, two of the great pioneers of
Expressionism.

*self-portrait_*A portrait of the artist by the artist. Self-
portraits are an interesting subgroup of portraiture and
can often be highly self-revelatory.

*Seven and Five Society_*The Seven and Five
Society was formed in London in 1919 and held its
first exhibition the following year. Initially it was

a conservative group and can be seen as a British manifestation of the 'return to order' that followed the First World War. The first exhibition catalogue explained that the society was not formed 'to advertise a new "ism" ... [we] feel that there has of late been too much pioneering along too many lines in altogether too much of a hurry'. This perfectly encapsulates the 'return to order' attitude. However, in 1924 Ben Nicholson, one of the pioneers of abstract art in Britain, joined the Seven and Five. He was followed by other modernists including Barbara Hepworth, Henry Moore and, later, John Piper. They effectively hijacked the group, expelling the non-modernists. In 1935 they renamed it the Seven and Five Abstract Group and held the first all-abstract exhibition in Britain at the Zwemmer Gallery in London.

significant form_ see formalism

simulacrum_ A term from Greek Platonic philosophy
that meant a copy of a copy of an ideal form. In postmodernist thought, particularly through the writings of Gilles Deleuze and Jean Baudrillard, the term has been revived in the context of arguments about the relationship between an original work of art and its replication. For Baudrillard the simulacrum takes precedence over the original, with the effect that the original is no longer relevant.

simultanism_ The term invented by French painter
Robert Delaunay to describe the abstract painting developed by him and his wife Sonia Delaunay from about 1910. Their work was also named Orphism by the poet and critic Guillaume Apollinaire. The term is derived from the theories of M-E. Chevreul whose book of colour theory *De la loi du contraste simultanée des couleurs* (On the law of the simultaneous contrast of colours) was published in Paris in 1839. It had an

increasing impact on French painters, particularly the
Impressionists and Post-Impressionists, and even more
so on the Neo-Impressionists. The Delaunays' paintings
consisted of interlocking or overlapping patches, or
planes, of contrasting (or complementary) colours. In
Chevreul's theory, and in reality, contrasting colours
brought together (i.e. simultaneous) enhance each other,
giving the painting greater intensity and vibrancy of
colour. The compositions were initially derived from
architecture but by 1912 Delaunay had begun to make
paintings in totally abstract circular formats. These
compositions were still ultimately based on nature,
however.

*site-specific*_Refers to a work of art designed
specifically for a particular location and that has an
interrelationship with the location. If removed from
the location it would lose all or a substantial part of
its meaning. Site-specific is often used to describe
installation works, and Land art is site-specific almost
by definition.

*Situationist International*_Revolutionary alliance
of European avant-garde artists, writers and poets
formed at a conference in Italy in 1957 (as Internationale
Situationiste or IS). It combined two existing groupings,
the Lettrist International and the International Union
for a Pictorial Bauhaus. The leading figure was the
writer and film maker Guy Debord and the group
also prominently included the former CoBrA painter
Asger Jorn. The former CoBrA artist Constant was
also a member, and the British artist Ralph Rumney
was a co-founder of the movement. The IS developed a
critique of capitalism based on a mixture of Marxism
and Surrealism, and Debord identified consumer society
as the Society of the Spectacle in his influential 1967
book of that title. In the field of culture Situationists
wanted to break down the division between artists

and consumers and make cultural production a part of everyday life. Situationist ideas played an important role in the revolutionary Paris events of 1968. The IS was dissolved in 1972.

*Social Realism*_Refers to any realist painting or other work that depicts everyday life and also carries a discernible social comment or message. Common in Western art from at least the eighteenth century onwards. Not to be confused with Socialist Realism.

*Socialist Realism*_A form of modern realism imposed in Russia by Stalin following his rise to power after the death of Lenin in 1924. The doctrine was formally proclaimed by Maxim Gorky at the Soviet Writers Congress of 1934, although not precisely defined. In practice, it meant painting using realist styles to create rigorously optimistic pictures of Soviet life. Any pessimistic or critical element was banned and it was therefore quite simply propaganda art. It has an ironic resemblance to the Fascist realism imposed by Hitler in Germany (see degenerate art). Outside the Soviet Union, socialist artists produced much freer interpretations of the genre.

*software art*_In the 1960s, software programs were the digital tool with which artists could create art on computers. Since then, these programs have become so sophisticated that they can now be considered the work of art rather than just a facilitator. Software art is closely related to net art because of its reliance on the World Wide Web as a tool for dissemination. Often Software art parodies or reconfigures existing computer programs. *Web Stalker*, created by the art collective I/O/D, was a radical reinterpretation of an internet browser and Adrian Shaw's *Signwave* parodied the computer program Adobe Photoshop. The rise of Software art has led to several international new media

festivals, namely FILE (Electronic Language
International Festival) held in São Paulo in Brazil and
transmediale in Berlin. The rise of Software art has
provoked questions about the de-materialisation of art
and culture and how this has had an effect on the world
of <u>Conceptual art</u>.
(See also <u>browser art</u>; <u>net art</u>)

*solarisation*_Discovered accidentally by Man
Ray and Lee Miller, solarisation is created by briefly
exposing a partially developed <u>photograph</u> to light,
before continuing processing. Man Ray quickly adopted
solarisation as a means to 'escape from banality' and
often applied the technique to photographs of female
nudes, using the halo-like outlines around forms and
areas of partially reversed tonality to emphasise the
contours of the body.

*Sots art*_A descriptive term since 1972 that takes
its name from 'Sots'ialisticheskiy Realism (Socialist
Realism) and <u>Pop 'art'</u>. It describes a kind of art that

Socialist Realism
André Fougeron
Martyred Spain 1937
Oil on canvas
98.2 x 153.9
Tate. Presented by the Friends
of the Tate Gallery 2001

appeared in the USSR in the 1970s and 1980s which adapts the techniques of <u>Socialist Realism</u> to critique its ideological basis and question its cultural implications.

*sound art*_Art about sound, using sound both as its medium and as its subject. It dates back to the early inventions of <u>Futurist</u> Luigi Russolo who, between 1913 and 1930, built noise machines that replicated the clatter of the industrial age and the boom of warfare, and subsequent experiments in the <u>Dada</u> and <u>Surrealist</u> movements. Marcel Duchamp's composition *Erratum Musical* featured three voices singing notes pulled from a hat, a seemingly arbitrary act that had an impact on the compositions of John Cage, who in 1952 composed *4'33"*, a musical score of four minutes and thirty-three seconds of silence (four minutes thirty-three seconds is 273 seconds. The temperature minus 273 Celsius is absolute zero). By the 1950s and 1960s visual artists and composers like Bill Fontana were using <u>kinetic</u> sculptures and <u>electronic media</u>, overlapping live and pre-recorded sound, in order to explore the space around them. Since the introduction of digital technology sound art has undergone a radical transformation. Artists can now create visual images in response to sounds, allow the audience to control the art through pressure pads, sensors and voice activation, and in examples like Jem Finer's *Longplayer*, extend a sound so that it resonates for a thousand years.

*Spazialismo*_Italian movement *Movimento Spaziale* (spacialist movement or spacialism) started by the Argentine-born Italian artist Lucio Fontana after his return to Italy from Argentina in 1947. The movement was launched in 1947 with the first *Manifiesto Spaziale* (spatialist manifesto – several more followed) in which Fontana developed the ideas of the *Manifiesto Blanco* issued at the <u>School of Altamira</u> in Buenos Aires the

year before. There he had called for an art that embraced science and technology and made use of such things as neon light, radio and television. In 1949 Fontana installed his *Ambiente Spaziale* at the Galleria del Naviglio in Milan. It consisted of an <u>abstract</u> object painted with phosphorescent paint and lit by a neon light and was a pioneering example of what became known as <u>installation</u>. He subsequently went on to make the works on <u>canvas</u> to which he gave the generic title of *Concetto Spaziale* (spatial concept) although continuing to make installations using light. The basis of the Concetto Spaziale works was the piercing or slashing with a razor of the canvas to create an actual dimension of space. Fontana made a long series of these and extended the idea into <u>sculpture</u> in his *Concetto Spaziale, Natura* series. Other Spazialismo artists included Giovanni Dova and Roberto Crippa.

*De Stijl*_ Name of journal founded in 1917 in Holland by pioneers of <u>abstract art</u> Piet Mondrian and Theo van Doesburg. This Dutch term means 'style'. The name De Stijl also came to refer to the circle of artists that gathered around the publication. *De Stijl* became a vehicle for Mondrian's ideas on art, and in a series of articles in the first year's issues he defined his aims and used, perhaps for the first time, the term <u>Neo-Plasticism</u>. This became the name for the type of abstract art he and the De Stijl circle practised. It was based on a strict geometry of horizontals and verticals. Other members of the group included Bart van der Leck, Georges Vantongerloo and Friedrich Vordemberge-Gildewart, as well as the architects Gerrit Rietveld and J.J.P. Oud. Mondrian withdrew from De Stijl in 1923 following Van Doesburg's adoption of diagonal elements in his work. Van Doesburg continued the publication until 1931. De Stijl had a profound influence on the development both of abstract art and modern architecture and design.

***still life*_**One of the principal genres (subject types) of Western art. Essentially, the subject matter of a still life painting or sculpture is anything that does not move or is dead. So still life includes all kinds of man-made or natural objects: cut flowers, fruit, vegetables, fish, game, wine and so on. Still life can be a celebration of material pleasures such as food and wine, but it is often a warning of the ephemerality of these pleasures and of the brevity of human life (see memento mori). In modern art simple still life arrangements have often been used as a relatively neutral basis for formal experiment, for example by Paul Cézanne and the Cubist painters. Note the plural of still life is still lifes, and the term is not hyphenated.

***street art*_**Street art is a genre related to graffiti writing, but separate and with different rules and traditions. Where as modern-day graffiti revolves around 'tagging' and text-based subject matter, street art is far more open and is often related to graphic design. There are no rules in street art, so anything goes. However, some common materials and techniques include fly-posting (also known as wheat-pasting), stencilling, stickers, freehand drawing and projecting videos. Street artists will often work in studios, hold gallery exhibitions or work in other creative areas: they are not Anti-art, they simply enjoy the freedom of working in public without having to worry about what other people think. Many well-known artists started their careers working in a way that we would now consider to be street art, for example, Gordon Matta-Clark, Jenny Holzer and Barbara Kruger.

***Stuckism*_**Founded by Billy Childish and Charles Thomson in 1999, Stuckism is an art movement that is anti-conceptual and champions figurative painting. Thomson derived the name from an insult by the Young British Artist Tracey Emin, who told

her ex-lover Childish that his art was 'stuck, stuck, stuck'. Since its modest beginnings Stuckism is now an international art movement with over a hundred members worldwide. Childish left in 2001, but the group continues its confrontational agenda, demonstrating against events like the Turner Prize or Beck's Futures which the movement argues are among a number of art world events controlled by a small number of art world insiders.

*the Sublime*_Theory of art put forward by Edmund Burke in *A Philosophical Enquiry into the Origin of our Ideas of the Sublime and Beautiful* published in 1757. He defined the Sublime as an artistic effect productive of the strongest emotion the mind is capable of feeling and wrote 'whatever is in any sort terrible or is conversant about terrible objects or operates in a manner analogous to terror, is a source of the Sublime.' The notion that a legitimate function of art can be to produce upsetting or disturbing effects was an important element in Romantic art and remains fundamental to art today.

*Suprematism*_The name given by the Russian artist Kasimir Malevich to the abstract art he developed from 1913. The first actual exhibition of Suprematist paintings was in December 1915 in St Petersburg, at an exhibition called *O.10*. The exhibition included thirty-five abstract paintings by Malevich, among them the famous black square on a white ground (Russian Museum, St Petersburg) which headed the list of his works in the catalogue. In 1927 Malevich published his book *The Non-Objective World*, one of the most important theoretical documents of abstract art. In it he wrote: 'In the year 1913, trying desperately to free art from the dead weight of the real world, I took refuge in the form of the square.' Out of the 'Suprematist square', as he called it, Malevich developed a whole range of forms

Surrealism
Max Ernst
Men Shall Know Nothing of This
1923
Oil on canvas
80.3 x 63.8
Tate. Purchased 1960

including rectangles, triangles and circles often in intense and beautiful colours. These forms are floated against a usually white ground, and the feeling of colour in space in Suprematist painting is a crucial aspect of it. Suprematism was one of the key movements of modern art in Russia and was particularly closely associated with the Revolution. After the rise of Stalin from 1924

and the imposition of Socialist Realism, Malevich's
career languished. In his last years before his death in
1935 he painted realist pictures. In 1919 the Russian
artist El Lissitsky met Malevich and was strongly
influenced by Suprematism, as was the Hungarian-born
Laszlo Moholy-Nagy.

*Surrealism*_Movement launched in Paris in 1924
by French poet André Breton with publication of his
Manifesto of Surrealism. Breton was strongly influenced
by the theories of Sigmund Freud, the founder of
psychoanalysis. Freud identified a deep layer of the
human mind where memories and our most basic
instincts are stored. He called this the unconscious,
since most of the time we are not aware of it. The
aim of Surrealism was to reveal the unconscious and
reconcile it with rational life. The Surrealists did this in
literature as well as art. Surrealism also aimed at social
and political revolution and for a time was affiliated
to the Communist party. There was no single style of
Surrealist art but two broad types can be seen. These
are the oneiric (dream-like) work of Salvador Dalí, early
Max Ernst, and René Magritte, and the Automatism of
later Ernst and Joan Miró. Freud believed that dreams
revealed the workings of the unconscious, and his
famous book *The Interpretation of Dreams* was central
to Surrealism. Automatism was the Surrealist term for
Freud's technique of free association, which he also
used to reveal the unconscious mind of his patients.
Surrealism had a huge influence on art, literature and
the cinema as well as on social attitudes and behaviour.

*symbolism*_Term coined in 1886 by the French critic
Jean Moréas to describe the poetry of Mallarmé and
Verlaine. It was soon applied to art where it describes
the continuation, in the face of Impressionism,
realism and naturalism, of traditional mythological,
religious and literary subject matter, but fuelled by new

psychological content, particularly erotic and mystical. Symbolism was a complex international phenomenon but is seen as especially French (Gustave Moreau, Odilon Redon, Paul Gauguin), Belgian (Fernand Khnopff, Jean Delville) and British (Dante Gabriel Rossetti, Edward Burne-Jones, George Frederic Watts, Aubrey Beardsley).

*synthetism*_A term associated with the style of symbolic representation of observed reality favoured by Paul Gauguin and his followers at Pont-Aven in the 1880s, whereby the artwork, rather than offering naturalistic representation, synthesises the subject-matter with the emotions of the artist and aesthetic concerns. An exhibition of 'Synthétisme' was mounted by the Pont-Aven artists in 1889 and the 'Groupe Synthétiste', including Gauguin and Emile Bernard, was founded in 1891. Another follower of the movement, Paul Sérusier, founded the Nabis group.

*Systems art*_Loosely describes a group of artists who radically rethought the object of art in the late 1960s early 1970s. They sought to connect with the political developments of the decade and make their art more responsive to the world around them. Building on the structures of Minimal art and Conceptual art, they reacted against art's traditional focus on the object by adopting experimental aesthetic systems across a variety of media including photography, dance, performance, painting, installation, video and film. Examples of Systems art include Richard Long, who imposed rigid structures to his walks across the landscape.

*Tachisme*_French term for the improvisatory non-geometric <u>abstract art</u> that developed in Europe in the 1940s and 1950s and was the European equivalent to <u>Abstract Expressionism</u> in America. Tachisme is virtually synonymous with <u>Art Informel</u>. The name derives from the French word *tache*, meaning a stain or splash (e.g. of paint). The introduction of the term to describe these post-war developments is usually credited to the critic Pierre Guéguen in 1951. However, it was used in 1889 by the critic Félix Fénéon to describe the <u>Impressionist</u> technique, and again in 1909 by the artist Maurice Denis referring to the <u>Fauve</u> painters.

*tactical media*_Refers to a reawakening of social, political and media activism brought on by access to cheap forms of communication, in particular the Internet (see <u>net art</u>). The phrase is thought to have come from the French philosopher Michel de Certeau, who suggested in his 1974 essay 'The Practice of Everyday Life' that as consumers were arguably the producers within our society, it was up to us to infiltrate the structures of power in a creative manner which would ultimately undermine them. Actions have included Flash-mob events, in which hundreds of people descend on a designated place at a particular time, clever manipulation of funding applications and rogue websites that purport to be official domains. Groups like Critical Art Ensemble print manuals on how to hack into classified websites, and the annual self-publishing event Publish and be Damned promotes fanzines, novels and comics, bypassing the usual official channels.

*telematic art*_Alain Minc and Simon Nora first used the term 'telematic' in the late 1970s to describe the way computers transmit information. In the early 1990s, the British artist and theorist Roy Ascott coined the term telematic art to describe art that uses the Internet and

other digital means of communication, like email and
mobile phones, in order to make a more interactive form
of art. Much of the writing surrounding telematic art
focuses on the human aspect of the medium; the desire
to communicate with another, even in the virtual world,
and how this is central to the creation of the medium.
(See also browser art; digital art; net art; software art)

tempera_ The technique of painting with pigments
bound in a water-soluble emulsion, such as water and
egg yolk, or an oil-in-water emulsion such as oil and
a whole egg. Some tempera paints are made with an
artificial emulsion using gum or glue. Traditionally
applied to a rigid support such as a wood panel, the
paint dries to a hard film.

time-based media_ Refers to art that is dependent
on technology and has a durational dimension. Usually
time-based media are video, slide, film, audio or
computer based and part of what it means to experience
the art is to watch it unfold over time according to
the temporal logic of the medium as it is played back.
Early examples of time-based media date back to the
1960s, in particular the art of Bruce Nauman, who would
record happenings to be played back in the gallery. His
Performance Corridor, made in 1968, was a recording of
a performance in which people edged their way down a
dark narrow tunnel. Since Nauman's early explorations,
artists have also experimented with the elasticity of
the medium in order to stretch time and space. In 1993
Douglas Gordon slowed down Alfred Hitchcock's film
Psycho to twenty-four hours.

tondo_ A circular painting or relief sculpture.
(See also format)

tone_ In painting, tone refers to the relative lightness or
darkness of a colour (see also chiaroscuro). One colour

can have an almost infinite number of different tones. Tone can also mean the colour itself. For example, when Vincent van Gogh wrote in a letter 'I exaggerate the fairness of the hair, I even get to orange tones, chromes and pale citron-yellow', he is referring to those colours at a particular tonal value. The term seems to have come into widespread use with the rise of painting directly from nature in the nineteenth century, when artists became interested in identifying and reproducing the full range of tones to be found in a particular subject. This in turn led to an interest in colour for its own sake and in colour theory. However, tone is also a musical term and its use in relation to painting reflects the theory that became increasingly important from about 1870, that painting can be like music. From about that time the painter J.A.M. Whistler, for example, made paintings using a very limited range of closely related tones of just one or two colours, and gave them musical titles. This kind of painting is known as tonal painting. In 1908, in his *A Painter's Notes*, Henri Matisse wrote: 'When I have found the relationship of all the tones the result must be a living harmony of all the tones, a harmony not unlike that of a musical composition.'

*Transavanguardia*_Italian Neo-Expressionist group. The term was coined by the critic Achille Oliva in his texts for an exhibition he organised in 1979 in Genanzzano titled *Le Stanze*. The leading Italian Transavanguardia artists were Sandro Chia, Francesco Clemente, Enzo Cucchi, Nicolo de Maria and Mimmo Paladino.

*triennial*_A large-scale contemporary art exhibition that occurs every three years. Like a biennial it is often attached to a particular place and is typified by its national or international outlook. The Tate Triennial showcases new developments in British art and the Asia-Pacific Triennial of Contemporary Art, which was

established in 1993, is the only major international exhibition to focus on art from Asia, the Pacific and Australia.

*triptych*_Painting in three panels.

*trompe l'oeil*_see illusionism

Transavanguardia
Sandro Chia
Water Bearer 1981
Oil and pastel on canvas
206.5 x 170
Tate. Purchased 1982

*ugly realism*_A style of <u>painting</u> developed in
the 1970s that combined fine draughtsmanship with
images that were considered ugly. These were rendered
with a chilling photographic clarity designed to
highlight the shallow and alienating brutality of the
modern world. Many of the artists associated with the
movement were originally members of the cooperative
gallery Grossgörschen 35, founded in Berlin in 1964.
Arguments between the group led to a split in 1966,
and Ulrich Baehr, Charles Diehl, Wolfgang Petrick and
Peter Sorge went on to start the Galerie Eva Poll, which
became home to this new brand of <u>realism</u>.

*underground art*_First used in relation to the
cultural phenomenon of the 1960s and early 1970s,
exemplified in what was called the underground press,
magazines like *Oz magazine*, *International Times*, *East
Village Other* and *The San Francisco Oracle*, and in the
comix of West Coast America. Its precursors were the
Beat Generation and the Paris Existentialists, groups
that were perceived to exist outside or on the fringes of
popular culture. These days the term underground art
is used to describe a subculture of art, like <u>graffiti art</u> or
<u>comic strip art</u>. Since the late 1990s the Internet
has become a forum for underground art thanks to its
ability to communicate with a wide audience for free
and without the support of an art establishment (see
<u>net art</u>).

*Unit One*_British group formed by Paul Nash in 1933
to promote modern art, architecture and design. At this
point, the two major currents in modern art were seen
as being <u>abstract art</u> on the one hand and <u>Surrealism</u> on
the other. Unit One embraced the full spectrum, Nash
himself made both abstract and Surrealist work in the
mid-1930s and played a major part in organising the
International Surrealist Exhibition in London in 1936.
The launch of the group was announced in a letter from

Nash to *The Times* newspaper, in which he wrote that
Unit One was 'to stand for the expression of a truly
contemporary spirit, for that thing which is recognised
as peculiarly of today in painting, sculpture and
architecture'. The first and only group exhibition was
held in 1934 accompanied by a book Unit One, subtitled
The Modern Movement in English Architecture,
Painting and Sculpture. It consisted of statements by
all the artists in the group, photographs of their work,
and an introduction by the critic and poet Herbert
Read, who was an important champion of modernism in
Britain. The other artists involved were John Armstrong,
John Bigge, Edward Burra, Barbara Hepworth, Henry
Moore, Ben Nicholson, Edward Wadsworth and the
architects Welles Coates and Colin Lucas.

V

*vanishing point*_see <u>perspective</u>

*vanitas*_see <u>memento mori</u>

vellum_Vellum and parchment are made from the skins of calves, goats and sheep. While there is no sharp distinction between the two, vellum is generally a finer quality than parchment, since it is made from younger hides and so is smoother and has fewer or finer hair follicles. Parchment, made from the skins of older animals, tends to be coarser.

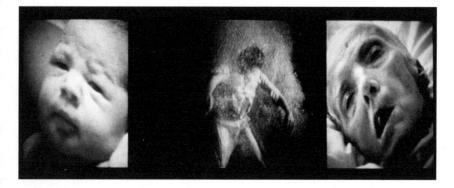

video art
Bill Viola
Nantes Triptych 1992
Video and mixed media
Duration: 29 min. 46 sec.
Tate. Purchased with assistance from the Patrons of New Art through the Tate Gallery Foundation and from The Art Fund 1994

*Venice Biennale*_see <u>biennial</u>

verism_From the Italian term *verismo*, meaning <u>realism</u> in its sense of gritty subject matter. It was originally applied around 1900 to the violent melodramatic operas of Puccini and Mascagni. In <u>painting</u> it has come to mean realism in its modern sense of representing objects with a high degree of truth to appearances.
(See also <u>modern realism</u>; <u>naturalism</u>)

video art_The introduction of video in the 1960s radically altered the progress of art. The most important aspect of video was that it was cheap and easy to make, enabling artists to record and document their

performances easily. This put less pressure on where their art was situated, giving them freedom outside the gallery. One of the early pioneers of video art was Bruce Nauman, who used video to reveal the hidden creative processes of the artist by filming himself in his studio. As video technology became more sophisticated, the art evolved from real-time, grainy, black and white recordings to the present-day emphasis on large-scale installations in colour. Bill Viola's multi-screened works are theatrical and often have a narrative; and Gillian Wearing uses a documentary style to make art about the hidden aspects of society.

virtual reality_ The computer scientist Jaron Lanier popularised the term virtual reality in the early 1980s to describe a technology that enables a person to interact with a computer-simulated environment, be it based on a real or an imagined place. Virtual reality environments are usually visual experiences, displayed on computer screens or through special stereoscopic displays. Some simulations include additional sensory information such as sound through speakers or headphones. Explorations into virtual reality by artists began in a relatively modest way; in 2002 the duo Langlands and Bell created a virtual reality tour of Osama Bin Laden's hideout in Afghanistan and audiences were invited to navigate the building using a joystick. With the introduction of Second Life on the Internet, artists are now installing galleries and staging virtual exhibitions in the alternative virtual world. The Dutch team Art Tower stage exhibitions and sell art in Second Life and Cao Fei, who represented China at the 2007 Venice Biennale, reproduced her exhibition in the Chinese pavilion in Second Life.

vitrine_ A large, glazed cabinet used for displaying art objects. Often used in museums, the vitrine was appropriated by artists like Joseph Cornell in the 1950s

and Joseph Beuys in the mid-1960s to display unusual materials they invested with spiritual or personal significance. Other artists who have used vitrines in their work include the American Neo-Geo artist Jeff Koons and the British sculptor Rebecca Warren.

*Vorticism*_ A British avant-garde group formed in London in 1914 by the artist, writer and polemicist Wyndham Lewis. It started with the Rebel Art Centre, which was founded by Lewis as a meeting place for artists to discuss revolutionary ideas and teach non-representational art. Their only group exhibition was held in London the following year. Vorticism was launched with the first issue (of two) of the magazine *Blast* which contained among other material two aggressive manifestos by Lewis 'blasting' what he considered to be the effeteness of British art and culture and proclaiming the Vorticist aesthetic: 'The New Vortex plunges to the heart of the Present ... we produce a New Living Abstraction'. Vorticist painting combines Cubist fragmentation of reality with hard-edged imagery derived from the machine and the urban environment, to create a highly effective expression of the Vorticists' sense of the dynamism of the modern world. It was in effect a British equivalent to Futurism, although with doctrinal differences – and Lewis was deeply hostile to the Futurists. Other artists were Lawrence Atkinson, Jessica Dismorr, Cuthbert Hamilton, William Roberts, Helen Saunders, Edward Wadsworth, and the sculptors Jacob Epstein and Henri Gaudier-Brzeska. David Bomberg was not formally a member of the group but produced major work in a similar style. The First World War brought Vorticism to an end, although in 1920 Lewis made a brief attempt to revive it with Group X.

*watercolour_*A medium or work of art made with
paint consisting of fine pigment particles suspended
in an aqueous binder that usually consists of gum,
glucose, glycerine and wetting agents, applied to paper.
As watercolour is semi-transparent, the white of the
paper gives a natural luminosity to the washes of colour.
White areas of the image are often left unpainted to
expose the paper. Watercolour paints are sold as cakes
of dry paint or as liquid in tubes, to which water is
added. The paint can be applied in various techniques
such as wet-on-wet and wet-on-dry to obtain different
effects.

*watermark_*An image or mark in a sheet of paper
visible when viewed by transmitted light. It is created
using a pattern of wire sewn into the mould on which
the sheet of pulp is dried; the paper that settles above
the wires is thinner, and so more translucent. The
image usually represents the papermaker's trademark
design or logo, sometimes with a name, initials or
date. Although more common in historical papers
(handmade), modern specialist printmaking papers
often contain a watermark.

*welding_*The process of joining two pieces of metal
by softening or melting both surfaces to be joined by
the application of heat.

*white cube_*Refers to a certain gallery aesthetic that
was introduced in the early twentieth century in response
to the increasing abstraction of modern art. With an
emphasis on colour and light, artists from groups like
De Stijl and the Bauhaus preferred to exhibit their works
against white walls in order to minimise distraction. The
white walls were also thought to act as a frame, rather
like the borders of a photograph. A parallel evolution in
architecture and design provided the right environment
for the art. The white cube was characterised by its

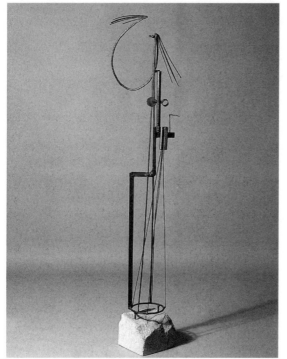

welding
Julio González
Maternity 1934
Steel
130.5 x 40.6 x 23.5
Tate. Purchased 1970

square or oblong shape, white walls and a light source
usually from the ceiling. In 1976 Brian O'Doherty wrote
a series of essays for *Art Forum* magazine, later turned
into a book called *Inside the White Cube*, in which he
confronted the modernist obsession with the white cube
arguing that every object became almost sacred inside it,
making the reading of art problematic.

*wood engraving*_A printmaking method distinct
from woodcut in that the line is incised into the
woodblock, rather than the background being cut away
to leave a line in relief. So it is an intaglio method.
Wood engraving is usually done on the end grain of a
block of boxwood, which is very hard, and so extremely
fine detail is possible. Wood engraving became
widely used in the nineteenth century as a method of
reproducing pictures in books, newspapers and journals

before the invention of photo-mechanical methods of reproduction, but was also occasionally used by artists, such as Edward Calvert, as an original printmaking medium.

woodcut_A method of relief printing from a block of wood cut along the grain. The block is carved so that an image stands out in relief. The relief image is then inked and paper placed against its surface and run through a press. It is possible to make a woodcut without a press (Japanese Ukiyo-e prints, for example) by placing the inked block against a sheet of paper and applying pressure by hand. Woodblock printing was used in Europe from the twelfth century, at first for printing textiles, though images were printed on paper by the late fourteenth century.

Works Progress Administration (WPA)_
see Federal Art Project

*World of Art (Mir Iskutsstva)_*A Russian avant-garde artistic group promoted through the journal of the same name that ran from 1898 to 1905. Serge Diaghilev was instrumental in founding the group and organising its first exhibition in St Petersburg in January 1899. The group offered a focus for Post-Impressionist, symbolist and aesthetic developments in Russian art, with particular emphasis on the history and folklore of Russia. Artists included Leon Bakst and Ivan Bilibin; newcomers in the final exhibition of the original group in 1906 included Alexei Jawlenski and Mikhail Larionov. The group's series of exhibitions was revived in 1910 by Alexandre Benois and ran until 1924; new members included Chagall, Kandinsky, El Lissitzky and Tatlin.

*Worpswede Group_*Worpswede is a village set in beautiful countryside in Lower Saxony, Germany, near the city of Bremen. In 1889 the painters Fritz

Mackensen, Otto Modersohn and Hans am Ende moved there and founded an artists' colony. Worpswede painting was initially in the plein air tradition but later embraced more modern tendencies, particularly Expressionism. From the beginning they were closely connected with Carl Vinnen, who lived on his farm at Ostendorf, Bremerhaven. In 1892 they were joined by Fritz Overbeck, and in 1894 by Heinrich Vogeler. The most important early Worpswede artist is considered to be the pioneer Expressionist Paula Modersohn-Becker, who moved there in 1898 and remained until her death in 1907. The poet Rainer Maria Rilke was a major literary figure who lived there from 1900 to 1902. After the first phase, Worpswede continued to attract artists and today remains a focus for artistic and literary events.

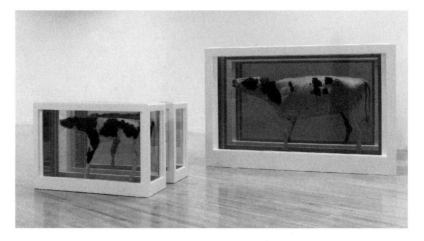

Young British Artists
Damien Hirst
Mother and Child Divided
Exhibition Copy 2007 (original 1993)
Glass and steel tanks, GRP composites, glass, silicon, cow, calf and formaldehyde solution
Dimensions variable
Tate. Presented by the artist 2007

*Young British Artists (YBAs)*_In the late 1980s British art entered what was quickly recognised as a new and excitingly distinctive phase, the era of what became known as the YBAs – the Young British Artists. Young British Art can be seen to have a convenient starting point in the exhibition *Freeze* organised, while he was still a student at Goldsmiths College in London in 1988, by Damien Hirst, who became the most celebrated, or notorious, of the YBAs. Goldsmiths, which was attended by many of the YBAs, and numbered Michael Craig-Martin among its most influential teachers, had been for some years fostering new forms of creativity through its courses that, for example, abolished the traditional separation of the media of art. The label YBA turned out to be a powerful brand and marketing tool, but of course it concealed huge diversity. Nevertheless certain broad trends, both in form and theme, can be discerned. Formally, the era is marked by a complete openness towards the materials and processes with which art can be made and the form that it can take. Leading artists have preserved dead animals (Damien Hirst), crushed found objects with a steamroller (Cornelia Parker), appropriated objects from medical history (Christine Borland), presented their own bed as art (Tracey Emin),

made sculpture from fresh food, cigarettes or women's
tights (Sarah Lucas), made extensive use of film, video
and photography, used drawing and printmaking in
every conceivable way, increasingly developed the
concept of the installation (a multi-part work occupying
a single space) and, not least, refreshed and revitalised
the art of painting.

***Zero*_**Group Zero or Group 0, often referred to simply
as Zero. German group formed in Düsseldorf in 1957 by
Otto Piene and Heinz Mack, joined in 1960 by Gunther
Uecker. A number of other artists were associated or
exhibited with Zero, most notably Yves Klein and Jean
Tinguely, as well as Pol Bury and Daniel Spoerri. The
name refers to the countdown for a rocket launch and
according to the group is meant to evoke 'a zone of
silence [out of which develops] a new beginning'. Zero
was in reaction against the subjective character of the
prevailing Tachisme or Art Informel and practised a
form of kinetic art using light and motion that they felt
opened up new forms of perception. Three issues of a
journal, *Zero*, were published in April and October 1958
and July 1961. The group dissolved in 1966.

Copyright credits

Carl Andre © DACS, London/VAGA, New York 2008

Arman (Armand Fernandez) © ADAGP, Paris and DACS, London 2008

Francis Bacon © Estate of Francis Bacon. All rights reserved, DACS 2008

Georg Baselitz © Georg Baselitz

Joseph Beuys © DACS 2008

Pierre Bonnard © ADAGP, Paris and DACS, London 2008

Louise Bourgeois © Louise Bourgeois

Georges Braque © ADAGP, Paris and DACS, London 2008

Sergio de Camargo © The estate of Sergio de Camargo

Sandro Chia © DACS, London/VAGA, New York 2008

Tony Cragg © Tony Cragg

John Currin © John Currin, courtesy Sadie Coles HQ, London

Salvador Dalí © Salvador Dalí, Gala-Salvador Dalí Foundation, DACS, London 2008

André Derain © ADAGP, Paris and DACS, London 2008

Jim Dine © ARS, NY and DACS, London 2008

Marcel Duchamp © Succession Marcel Duchamp/ADAGP, Paris and DACS, London 2008

Sir Jacob Epstein © The Estate of Sir Jacob Epstein/Tate, London 2008

Max Ernst © ADAGP, Paris and DACS, London 2008

André Fougeron © ADAGP, Paris and DACS, London 2008

The works of Naum Gabo © Nina Williams

Gilbert & George © Gilbert & George

Julio González © ADAGP, Paris and DACS, London 2008

Dame Barbara Hepworth © Bowness, Hepworth Estate

Damien Hirst © Damien Hirst. All rights reserved, DACS 2008

Franz Kline © ARS, NY and DACS, London 2008

Oskar Kokoschka © Foundation Oskar Kokoschka/DACS 2008

Jeff Koons © Jeff Koons

Leon Kossoff © Leon Kossoff

Sol LeWitt © ARS, NY and DACS, London 2008

Roy Lichtenstein © The Estate of Roy Lichtenstein/DACS 2008

Richard Long © Richard Long

Arturo Martini © The estate of Arturo Martini

Henri Matisse © Succession H. Matisse/DACS 2008

Joan Miró © Succession Miro/ADAGP, Paris and DACS, London 2008

Henry Moore. Reproduced by permission of the Henry Moore Foundation

Ron Mueck © Anthony d'Offay, London
Bruce Nauman © ARS, NY and DACS, London 2008
Claes Oldenburg © Claes Oldenburg
Giuseppe Penone © Giuseppe Penone / DACS
Antoine Pevsner © ADAGP, Paris and DACS, London 2008
Pablo Picasso © Succession Picasso/DACS 2008
Arnulf Rainer © Arnulf Rainer
Paula Rego © Paula Rego
Cindy Sherman © Cindy Sherman
Sir Stanley Spencer © The Estate of Stanley Spencer 2008. All rights reserved DACS.
Tomoko Takahashi © Tomoko Takahashi
Georges Vantongerloo © DACS 2008
Victor Vasarely © ADAGP, Paris and DACS, London 2008
Bill Viola © Bill Viola Studio

All photography ©Tate Photography